Age of Liberation

Volume 1

Janet Kaufmann

First Printed in United Kingdom 2021

Published by Conscious Dreams Publishing
www.consciousdreamspublishing.com

Edited by Elise Abram

Typeset by Oksana Kosovan

ISBN: 978-1-913674-63-2

To Humanity

.

Contents

Preface

I am a Pioneer of Liberation. It is my soul's mission to share my path of Liberation with you that is visionary for humanity's Liberation at this auspicious time of change.

The old world is over, and the age of power and control over us, is coming to an end. The new age is all about freedom, happiness, love, unity, and liberation. Your Liberation. The change is coming through every single one of you.

In my book, I share a lot of spiritual and practical wisdom with you that I found on my own, discoveries of myself and the world on my groundbreaking path of Liberation.

This is no summary of other people's studies or books, and it is no religion. I have discovered all of the information I give you by myself through my own eyes and body on countless spiritual and physical travels, searching for the Truth. I would not have believed half of the things I say to be true if I had not found them out by myself. This is the key. All power and wisdom lie within you. You are the Universe in small.

You will find it by remembering who you truly are, by liberating yourself from everything that has ever limited you in every possible area of your life – absolute Liberation for your ultimate Freedom and happiness because every limit is an illusion.

This is an inspirational guidebook with practical instructions and excerpts of my story to achieve Liberation on every possible level of your life. I will show you the way for you to walk it by yourself, to see the beauty of the world through your eyes, and to live your life to the fullest.

This is a true story. May it inspire, enlighten, and empower those of you who have found it.

Those whom I cannot reach with my book, I might meet on the streets or in my dreams. We will recognise each other in our eyes and greet us with our smiles, the language of love. We will exchange deep complicity through the smallest gesture of our equal hearts. Our love will create ripple effects, and it will change the whole world.

I love you

Janet

I. Your World is as Big as You Make It

Your world is as big as you make it,
and mine has no limits

The adventures on the road are the best adventures.

How much do I love life out there, in the train stations of the world, in pubs trembling with life and music, in ancient wineries and cosy crofts together with all of the beautiful people I have met on the road, wandering about from place to place where every day is a new adventure. On the other hand, the life of luxury in places like Moscow, Monte Carlo, and St. Moritz, that I lived as well, and which makes an interesting contrast to what I like to call the real, authentic, exciting life. How much do I feel alive out there!

It all started there, in a big house and green garden in a small East German village in the Ore Mountains where I grew up. Well protected from the world, I spent most of my childhood outside, hidden in nature between vast fields and deep forests. I discovered the atlas and a book about the stars and planets at an early age. I was intrigued by mountain ranges, river courses, islands, and continents. I knew most capitals of foreign countries and the nature of the stars and planets before I even went to school. One day, I was sure I would become an astronaut.

When I grew older, my home started to feel constrained, and I found that people were constrained in their heads and beliefs. They had surrounded their homes, towns, and concepts of the world with fences they made up in their minds, and I had to break out.

I started to like all kinds of forbidden and exciting things, although my parents had raised me well. I learned to play the piano and many other wonderful things. I speak five languages fluently, lived, worked, and studied in eight different countries by now, travelled and will travel many more, and graduated in education, psychology, and foreign languages, and I became a teacher. I became many more things.

My twenties mainly consisted of parties and travel. I hated conformity and always found society uptight and boring. I never liked small-mindedness. I always had a bit of a rebellious nature despite being a happy, sunny person and a deep-thinker.

I was born with a strong sense of – and passion for – righteousness, justice, and Freedom, and I got into trouble for standing up for what I believed in many times in my early life. I found it hard every time I had to conform to society and culture's limiting established norms, and when I was made too much a part of the system that pressed me into a tiny role in which I was supposed to function. I suffered whenever I did not feel free.

My real breakthrough came along with a huge, life-changing event in my thirties. I really never expected anything like this to ever happen to me. It was beyond crazy, and it changed my life forever. I made a quantum leap in spiritual evolution and freed myself from everything from which one could possibly free oneself.

It is my soul's mission to share my experience and what I have learned on this journey of Liberation with you. My book is all about Freedom and I dedicate it to humanity to free yourselves, too. It is the spirit of our time. This is for your inspiration, liberation and expansion and because I love you. This is for you.

It starts with your mind because this is where everything starts. The greatest prison you can ever find yourself in is your own mind. Freedom starts as a belief. It becomes a feeling, and then it becomes your life. Some things may sound difficult to comprehend in this first chapter about the mind, but these are highly important first steps to true Liberation. You must understand how your mind works and how you master it to live your best, free, and happy life.

Spiritual wisdom and higher truth were not accessible for thousands of years, at least in Western cultures. Much of it has already been proven by science and quantum physics, but they still hardly find their way into the mainstream. The laws of Creation should be common knowledge that we should teach our children. If we were to know and apply this genius natural law, there would be no need for much of the oppressive man-made laws.

This ancient knowledge is becoming more and more of interest and importance in these times of change and Liberation. Your Liberation lies in your own hands, of course, as everything else does. You have to discover the truth by yourself. Discover yourself first, your hidden treasures, your gifts, and your powers. Your beautiful, unique self, your purity, and your innocence, as much as your shadows that are here to show you where the light is. You will change the world by changing yourself.

The mind is still a mystery to science and more powerful than you can imagine. The highest mastery is to live in the so-called zero-point-consciousness. It is a state of mind in which you live in the present moment without thinking most of the time. You live with an empty mind. It is being instead of thinking. Conscious thinking, on the other hand, is crucial. It means that, with awareness, you become the master of your own thoughts and of your subconscious mind. You are not a victim of your thoughts. It is a choice you make and it requires a lot of training. Everything is energy, and so are your thoughts and beliefs. Your beliefs are, form, and attract your reality. What you think, you create; what you believe, you are; and what you feel, you attract. Explore this truth for yourself.

Nothing you feel exists outside of you. You can only feel what already exists inside of you; otherwise, you could not feel it. Everything you feel is a reflection of your beliefs and experiences. There is nothing left to judge when you are free from beliefs and thoughts of ego based on separation, which is the opposite of love. Everything

is interconnected. There is only Oneness. You can only judge what does not fit into the small world you have made up in your mind. The world has no limits. Instead of judging, I observe, and everything *is*.

When you live at the zero-point, you become a powerful creator. You can create whatever you wish. You gain infinite peace of mind and stand in your greatest power. Life becomes fun, and you feel more alive than ever before. This is because you bring your full presence, your full awareness, your full focus, your entire consciousness into the present moment. You do not invest in thoughts that you do not wish to think about by choice and willpower. You do not lose energy unnecessarily when you stay at the zero-point.

This way, you will experience everything much more intensively and with full awareness. You pull in your higher self, your whole true self when you free yourself from untrue thoughts of ego and false beliefs. It takes time and can be a long process, but you will know when it has happened. Thoughts that do not leave you with peace of mind will continue to come up for you to realise that they are untrue. Your subconscious mind will always go back to them, contemplating until you realise that these untrue thoughts based on separation are to be let go of.

You will only reach constant peace of mind by enlightening and releasing all limiting and false beliefs and illusions about yourself and the world. You will give them up through a process of comprehension, forgiveness, acceptance, and with your free will to let go of what does not serve you anymore, together with the active choice of wanting to live in the present moment. This is an important process we have to constantly do with our minds to live with peace of mind, in Oneness and in the present moment, which is the key to happiness.

This process will open up and activate all of your chakras, your energy centres that get blocked by false and limiting beliefs and unhealed wounds and pain. Your chakras function like portals to the Universe, to the origin, to Creation itself. Once open and activated, you will become One with Creation, all-knowing and powerful. You will tap into the greatest life force, and you will become it. You will be Creation. You will be the Universe in small form. It exists inside of you. Everybody can reach this state of true power, Freedom, and happiness.

Our thoughts and beliefs create our realities. We can master our minds as to what we wish to create. Creation is made from the zero-point through focus. You need only focus on what you want to create by making conscious choices with your willpower, then you simply do it, or you don't do it. You have free choice. You are free. Become aware of that. You do not have to do anything except for what you wish to do. You can think, believe, and do whatever you want. It was only an illusion in your own head when you believed the opposite. You did not remember your own power and that you are the powerful creator of your own life.

There are endless possibilities in every moment, and I can choose the best option for me. In fact, the best option for me will always happen. It is the one that aligns and reflects my vibrational energy and consciousness. Living without any limiting beliefs can, therefore, make the impossible happen. You attract your reality through your frequency. You attract what you reflect.

When things do not work out, there is a reason, and there are better options that you might not know or be able to see yet. Appreciate what you have at this moment. Reflect on why you are here now and what your learning is in the here-and-now. This awareness will make you feel abundant and grateful. This is how you will attract new and great things into your life through your energy of abundance within. Focusing on what is

missing will cause more things to be missing. New things always align in perfect timing and as a reflection of your vibration. Trust.

When I do not fear or plan too much, I attract all the magic of the Universe. My life is full of beauty. I see and discover what you cannot see when you are imprisoned in limiting beliefs, in small houses and worlds, and inside of fears. All of the excitement of real-life happens outside of your comfort zones, in front of your door. Step out onto this beautiful stage of life. It is yours. There is nothing to fear. Fear is an illusion in your head, and it is a great teacher. Face it, and you will see how you will empower yourself by overcoming it. Turn it around. Become the opposite of your fear. Become power. Become love.

Every thought based on separation is untrue. There is only Oneness. One side cannot be without the other, like Yin and Yang, the perfect balance of both polar opposites into One. It is the universal principle of everything. As above so below.

I feel thoughts that are untrue as blocks of energy in my body which results in unwellness, dizziness, or pain in the respective chakra and area of my body. This ability became stronger the more I freed myself from false beliefs and illusions, which upgrades your vibration. This process is amplified by the increasing light that bombards the Earth and humanity. Of course, the awakening of humanity is set in a cosmic event, depending on the constellation of the stars and planets. Those who first awakened are the pioneers who share the truth with you now as I do, and there are many more.

Everything is interconnected, and nothing ever happens by chance. Coincidences do not exist, and there are higher purposes and greater stories behind the one-

dimensional narrative story that is the only one you often get to hear. The truth will come to those who seek it.

Being in tune with your spiritual side means you become the embodiment of your higher-self, of your true self – when you are what you are – is a process that strengthens your spiritual gifts and your intuition that you will learn to listen to and follow. This is the best guidance you can get. You will feel what is right and what is wrong, what is true and untrue. This skill got stronger the more I became a body of light through my expansion of consciousness by removing all existing illusions and releasing everything in which I ever believed was untrue.

With time, instead of being judgmental, I became more compassionate and understanding of bad events and news, the chaotic situation of the world, and people's actions not based on love. I knew that the world and the reality of those who had not reached a state of an enlightened mind were different from me, but I could not judge anymore, and I did not feel separated from anyone because I am aligned with love through my expanded consciousness and perception, which made me grow empathic and understanding.

Everybody perceives a different reality according to their beliefs and vibrations. There is 3d, 4d, 5d, up to 12d reality. Your reality and how you experience the world are reflections of your consciousness. Living at a high vibration will make you experience a high vibrational world, a beautiful world that you will love. Living at a low vibration will do the opposite. If you feel miserable, you will perceive the world as a horrible one. The lower your vibration, the lower the dimension of reality in which you live.

Different dimensions coexist together at the same time, and one can jump and shift dimensions or stabilise at a high vibrational consciousness or dimension. This is why

bad things or news from so-called 3d reality leaves me mostly untouched. I recognise them and can feel compassion as an observer, but since they are of a lower vibrational reality than my own, they can not affect me or form my reality.

My expanded consciousness makes me see the bigger picture of things. I see things from a bird's-eye view and through my open third eye, my pineal gland. I see a multidimensional reality consisting of many layers instead of a one-dimensional reality in the illusion of the matrix. I can see how things are interconnected and why and how they correlate. Seeing things from a higher perspective makes you understand the cause and effects of many things.

The current state of the world is a reflection of the collective consciousness of humanity. Illness and imbalance are the results of a world of fear, separation, control, and power, of a limited belief system and unhealthy ways of life.

You are much less likely to get ill when you live at a high vibration of love which boosts your immune system like nothing else. Fear does the opposite. It disempowers you and makes you feel like a victim. You always have a choice of the reality in which you want to believe. Your beliefs are your reality. You have free choice: fear or love. Choose wisely.

Seen from a higher perspective, the lockdown serves as a break for the world and a time to reflect on ourselves, our beliefs, and our lifestyles. It is a pause from consumption and a stopping of the never-sleeping machinery. It is an opportunity to question the world in which we live with its powers that be, its old, rigid routines, self-evident standards, and everything else that comes up for you in your life. It serves your critical mind to pop up again and your awareness to grow. It serves the world to wake up. Remember that it is your free will and choice to believe what you wish and

to do what you want. Stand up for yourself, think for yourself, and change your life if you want to. Be free and be happy. Your happiness must never depend on the outside.

A crisis is a transition time into the new, which always comes with rupture and chaos. It happens to leave the old behind. The new is here. This is the age of Liberation. It is you and me and us together. It is one of the best chances you could ever get to finally break free. To create The New World together.

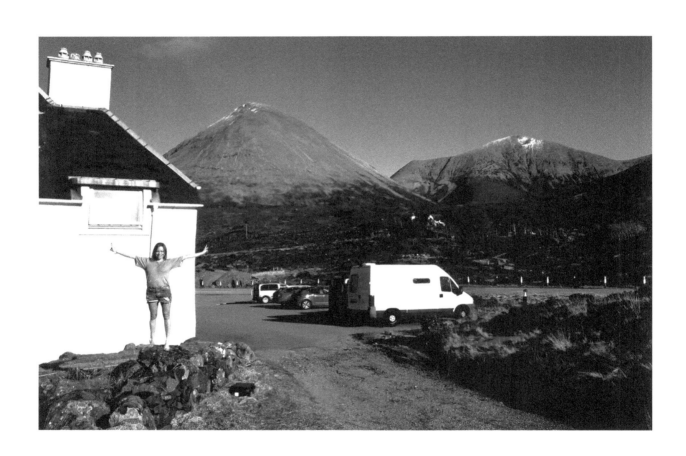

II. Breaking Free

Hello, stranger in the street,

Come on over, let's meet.

Tell me your story; I'll tell you mine.

You make me smile how you drink your glass of wine.

We share this moment and then part ways,

Strange encounters in a strange place

In this game with a strange name

Life will never be the same.

My transition into a new, free life was very rough rather than smooth. I was pushed out of the old, through events that (of course) my Higher Self had created for my own good, growth, and expansion, which is something I only fully comprehended much later.

My old life came completely crashing down when I lost everything I had ever owned at once: my belongings, my house, my job as a school teacher, my old friends and connections to my family, and all of my money. When it began, I felt like a load had fallen from me, and I went out into the blue with no destination, finally free. The road was my home, and a musician from Scotland was my company, but the happy times did not last very long as I lost my first true love.

This event was so traumatic that it broke me completely from the inside out, and my life fell apart at the same time. I started to wander around, moving from place to place. Sometimes, I was on the streets without money and shelter alone. I felt shipwrecked. Looking back, the times when I was in a tiny garden cottage in the Saxon hills and vinyards where I lived, worked, earned my bed and bread, and warmed myself at the fireplace, roasting chestnuts on cold November nights, – one of many places – seem a bit like a movie.

At that time, I fell deeper and deeper into the most painful heartache one could imagine, more painful than any physical pain I have ever experienced. It made no sense to me – how could the pain be so tremendous? I slowly comprehended that it was a very deep and old pain, originating from many previous lifetimes before the current one. I had never dealt with, nor have I been interested in, anything supernatural in my life before, but now it came without warning or preparation. It was the beginning of my soul's opening up to the spiritual realm and higher dimensions. To the truth, it started with past life memories that came out of the blue and shook me deeply.

I sank deeper and deeper into my pain, but I was lucky enough to find a snowed-in cottage in the Ore Mountain woods at the beginning of a long, cold winter in which I lived alone and isolated for months, and I fell into what is called the dark night of the soul.

Over the next few months, besides the unbearable pain of my broken heart and each of my cells hurting, all of my fears, past traumas, pain, and old wounds from early childhood and previous lifetimes I did not even know I had came forward for me to face and overcome. I was alone in the forest with no energy or hope left. I had to cross a huge field of snow on skis to get supplies once a week, but I hardly had any money, and sometimes I did not care anymore if I was dead or alive.

In my worst moments, when I was afraid to die, I started to feel as if my soul were greater and beyond my body and sometimes, not in my body for the first times, and I experienced my first astral travels and out-of-body-experiences. I saw countless synchronicities that showed me something much bigger. My third eye, my pineal gland, was opening. I felt an increasing energy rise inside of me. It was Kundalini energy, the strongest life energy that exists dormant in everyone's body, and that awoke inside of me through true love. It rose and pushed through my chakras, my energy centres, opening them. I had no control over it. It came with shots of incredibly hot fire-energy together with the increasingly deep inner-knowing that everything was different from what I had ever known. It came with an unstoppable desire and passion for changing the world.

The incredible darkness around me was sometimes lit up by beams of white light that overcame me. When I was in the deepest of pain, shivering in my body, afraid to die, I felt suddenly embraced by the greatest feeling of love one could imagine. The energy went through each of my cells, which immediately stopped hurting and expanded all around me. I rose from my deathbed like phoenix from the ashes,

suddenly understanding and knowing it all. My painful love was not lost – it had transformed into unconditional, universal love.

I experienced an expansion of my consciousness. My third eye opened. My upper chakras gave me a multidimensional perception. I was suddenly able to look through walls and behind masks. I saw the interconnection of all things, and everything made greater sense. It blew my mind. I had a spiritual awakening: a Kundalini awakening.

It took me many months to get used to my new open and continuously expanding perception. Over the next years, I went on a spiritual discovery, a rediscovery of the world, finding my balance and happiness, but most importantly, it was a discovery of my true self.

Everything I had never consciously chosen for myself had broken away. Beliefs that had been programmed into me, attachments to certain things, places, and people in my life were gone. In fact, everything that was not based on love, everything that was not true and that I had not chosen from my heart for myself but which was chosen for me or done out of ego broke away.

It happened not only in my life but with my naked self. All limiting beliefs about myself crashed. Every layer that had been placed upon my soul and life that was not the essence of my pure soul, my divine self, was brought to the surface. I had to face every existing illusion and let it go. It was the death of my ego, an ongoing process of years in which I found myself, my true self, my whole self.

I had to remove all of my fears, limiting beliefs, and attachments. I reintegrated lost aspects of my soul that came back to me when I overcame the past fears and traumas

I remembered. I embodied my higher self, my true self, and I came to know and love myself.

When I was ready, I left my remote cottage in the Ore Mountains. I wanted to live again. The worst of my fears, my traumatic past life and childhood memories had been remembered, healed, and washed away. We do this cleansing of our souls from everything we have ever faced in all of our lifetimes that has not been aligned with love and that stays in our energy fields to come back to our essences, our natures, our origins, and to love. It was a purification, a falling away of everything from my countless incarnations that did not consist of love and light.

I knew I had embarked on a spiritual journey of truth. I soon found pleasure in going out into the world again, and it was as if I was discovering everything anew. I was born again. I was called to go to Israel, where I had more past life memories and where I remembered my divinity and my innocence in a profound experience while bathing in a hidden waterfall at the Sea of Galilee, and I had countless intense spiritual experiences of that kind.

I started to understand that we can only fear what we carry inside ourselves and that we take on shadows in all of our incarnations through actions not based on love. I finally acknowledged my bravery for incredible lessons learned and that we experience on Earth to come to the conclusion that only love is real. I forgave myself and everybody else for actions that did not come from the purity of their hearts but from ego. This was how my body became more and more a body of light, through the cleansing of my shadows and dissolving all illusions within my consciousness, and this is how I ascended in vibration.

I soon understood that I could not discuss what I was going through with most people as they would not understand or believe me. I learned how to deal with my inner-spiritual processes and what I saw and knew on my own. I was incredibly lonely at times, but the faith and strength inside of me grew so strong that nothing could ever shatter me again, not after what I had been through – I had survived. The more I healed and loved myself, the more I loved everybody else, and my beautiful soul-family would soon turn up. I saw other people as my brothers and sisters, no matter their stage on this spiritual journey that we are all on together.

I did not wish to be labelled because I had a spiritual awakening that I rarely spoke about. I did not feel separate, or different from those who did not have such an experience because my love and understanding were constantly growing. I was expanding. The pain and shock from how it all started had been healed, and I just wanted to jump back into life again, have fun, and live life to the fullest. Nothing could ever limit me again. I became fearless and very happy. I am the great adventurer.

Completely liberated from my past and my own limiting beliefs, I started travelling again, mingling with many people and having many experiences in many different places. I left the secure path and took a leap of faith. I had nothing left in my life but myself, my faith, and a new strength, and that was much more than some wealthy people ever have. I stood on the springboard of the life of my dreams, and everything finally laid in my own hands.

I started doing things differently – my way. My Higher Self pushed me out of every possible comfort zone, fear, and limiting belief. The adventures were unique and life-changing, and they transformed me forever. I live Liberation on every possible level, living without limits, where anything is possible.

In the first years after my awakening, I had an increasingly strong desire to be alone in nature. I went far away from civilisation where everything seemed artificial to me. Society and the mechanism of money repelled me. Today, I know that I was searching for myself and happiness. I found both in the middle of nowhere, in the wilderness, far away from civilisation.

I went on various backpacking adventures. I felt a strong pull to go to Scotland and Ireland. I spent an amazing time in Israel, Greece, and Russia, too. My trips were all about discovery and not common tourist trips where you go to a hotel and lie on the beach. With time, I realised that I was doing much spiritual work on these trips, too. I will go into this later, but for now, note that we are always doing this, whether we know it or not. Everything is spiritual.

On the road, I learned to be brave, and I grew strong. I felt more alive than ever before. This is what I most loved about these trips. Life out there felt so much better than sitting, safe and warm in my apartment back when I used to live in the city, going to work every morning, shopping afterwards, then going home, watching the news, going to bed in the evening, and getting up at the same time in the morning to do the same thing over and over again with that strange feeling in my belly. The uncomfortable feeling of unhappiness and emptiness though I had and did everything society had taught me to do, left me feeling like a machine, half dead.

I could not stand it anymore. I was sick of the lifestyle I had not chosen for myself, but that which society and culture had told me was the way things were or had to be. For me, that was no longer true. I knew I was free and could do whatever I wanted, whenever I wanted. There, on the road, outside, I was amidst life, and I felt better than ever before. I could finally do all I wanted to do – what a feeling.

I did not care if I would stand in the middle of nowhere in the pouring rain at the end of the world, waiting for a lift, without a car passing by for hours. All that counted was that I was free, I felt alive, and life unfolded in all its magic in countless epic adventures.

I was once stranded in a city where I found no place to spend the night. I knew that the only solution was to stay awake all night, which is why I decided to hang out in the bars until they closed. I found myself immersed in an authentic Scottish night. I always connect with the locals with ease because I do not see myself separate or different from anyone. I never feel like a tourist. I am a passenger and part of it all and if I like it, I might stay longer. This is also the way how one truly gets to know places and people. That night, I was invited to sleep on the floor by two sweet ladies who had nothing themselves. Sleeping between them as they snored loudly along with their noisy dogs in their tiny, dirty, smokey, one-room apartment, I was safe and warm, but the most important thing was that it was an act of love. They had shown me love by sharing the little they had with me. I experienced that often. Those who had the least usually gave the most and had the biggest hearts. That night probably felt much better than a night spent at any luxury hotel by myself. How wonderful to be human and to love.

I love travelling. I do not book or plan too much on my journeys, taking it as it comes. That's the secret. Doors miraculously open when you walk in with an open heart and mind. That is how you attract adventures, love, fun, and community. I do most things on the spur of the moment, following my intuition. Plans do not work out well because they lie in the future, and the future doesn't exist. Not knowing is beautiful. The best things happen when you don't expect them.

One day, when I was working as a private teacher for the government in Russia, I had to make a decision: more money or more Freedom. You can probably guess what my choice was. I gave up the best-paid job and a life of luxury in five-star hotels with

a personal driver. I gave up every stability to go on a long backpacking trip instead, through Ireland, Wales, England, and Scotland. I knew I was on a spiritual journey that was not about money. I had a very strong desire to continue travelling, discovering, learning, growing, and expanding instead of just making money.

I studied cosmic law on that trip and discovered that everything magically unfolded when I did not fear or worry. The learning, adventures, and encounters were unforgettable. On the road and in many other random places, I met the most lovely people who showed me their favourite places, told me their life stories, invited me into their homes, and gave me secret tips on where to go next. On the way, I even found, and spontaneously bought, a camper van in which I continued my travels. It was a dream come true. I was totally independent and free. I had a home on wheels. It was more than perfect!

When I went back to Germany, where I had got myself a flat again in the city where I had gone to university in my twenties, I realised how much I hated city life. My soul suffered there, and I knew I was in the wrong place. Once again, I gave up every stability and was multiply rewarded. I packed three suitcases and everything I needed to survive, as well as my keyboard to play music and sing, which is one of my passions. I drove overnight to Scotland, which feels like my soul's home and where I lived for the next year on the Isle of Skye, where I had had the best time the previous year, working in a Scottish pub and living in a tiny, open-minded, wonderful community that I loved so much, between the Highlands and the wild Atlantic Ocean.

I know exactly how to go out there to live my life. I can find myself a room and a job anywhere I want to anytime. I have done so many times before. Everybody must know how to survive. You are here to live. Don't be afraid of life.

My life is not restricted in any way. I can do or not do whatever I want. Cultural limits do not apply to me. If I want, I will eat sardines for breakfast and eggs at night – why not? The thing is, I do not live in the framework of my head. I live from my heart and stomach, so my actions never come from a place of ego and are, therefore, loving and empowered. My energy is strong, and it circulates well in my body. I am not imprisoned by limiting beliefs, but it is more than that.

With time, I found out that the divine, universal principle of Yin and Yang apply to everything. I learned to master the perfect balance of my energy, of the masculine and feminine energies that we all carry inside of us, from within, finding the perfect balance between power, intuition, empathy, and wise action, to be my most powerful self. In the end, it does not matter what we call it – it is about feeling good and doing what we love, standing in our power, living from our hearts, being our whole, true selves. Life is fun when you do what you want. Nothing can stop you, and anything becomes possible.

Through the process of losing everything, I came to value everything on a much deeper level. I cannot be blinded by any amount of money. I see the beauty in the small things. My happiness does not depend on a big car, a nice house, or a well-paid job. My happiness is something far greater.

III. Mother Nature

Scotland, Magical Land of the Fairies

The elements, the Freedom, and eternal love, hiding your rugged beauty in misty rain — to those who understand you, you will lift the clouds and reveal your soul in all your glory. You made me find myself in the middle of nowhere and made me understand that nowhere is everywhere, that we are One, connected through each rock, leaf, whisper of the wind, and with every passenger we meet on this beautiful journey.

I had to go far to find myself. I had to be alone, in the middle of nowhere. I found myself, my power, and my Oneness in a place where I was amidst nothing but the elements of water, earth, air, and fire in the wilderness, where nothing existed but the rawness, sacredness, and divinity of Creation: the origin. This is how I realised from where I come from: the Source.

I found that place, that power, that Oneness, in Scotland. I later understood that I felt so great amidst the raw beauty of Creation because it reminded me of myself, of my Oneness with the origin. Scotland has also been my home in many previous incarnations, and I found many memories in the hills, the running waters, the sound, and the people, in the powerful energy and magic of the Highlands and the Atlantic Ocean. Scotland, for me, is a country of Freedom, joy, music, and life. It feels like the origin. It is, in fact, one of the oldest places on Earth in Creation.

In Scotland, I immersed myself so deeply in nature that sometimes I felt like the mountain. I felt powerful. There was an amazing exchange of energy between us. When I completely merged with nature, I could recognise the Earth's energy and vibration as a living being. We have a very strong connection. She is the mother, Mother Earth, and I deeply love her.

The more and more I attuned myself with love and Oneness by removing all false beliefs from my consciousness, the more my chakras, my energy centers were activated and wide open. My Higher Self, my true self came into body. I noticed this through a much wider perception and greater understanding and a general feeling of wellbeing, power and happiness.

With my open chakras that function like portals and connect us with the Universe that is conscious, I was more and more able to sense the energies and consciousness

of all living beings. I could communicate with mountains, trees and animals. Not only animals but every stone and plant on Earth that is alive has a consciousness. So do the elements that we ourselves are made of as well. There is a divine energy that pervades everything.

During my time on the Isle of Skye in Scotland, I felt a strong connection and energy exchange with the volcanoes that surrounded me. Through my third eye, I saw their physical and spiritual purposes of holding the balance of the electromagnetic field. I experienced them as creatures with their own specific energy and consciousness. They inherit an ancient power and wisdom that I am able to tune into. They are grounding me, give me power and bring me into my center.

I am able to sense and pick up information that comes in the form of energy and inner knowing from the land and sometimes from the past that can be installed in places. I have learned to tune into the Earth's energy everywhere I go by connecting to the land and to spirit. It is a never-ending discovery.

On my travels, I sometimes found places that felt heavy because of their dark, distorted energies due to battles and all sorts of crimes. I became aware that I was clearing such energies, washing them away and merging everything into Oneness with my own consciousness and through my own body. I realised this through a deep inner overwhelming knowing and I never spoke about it.

As a powerful creator, we are able to clear places that have been polluted by low energies through low vibrational collective consciousness or dark history. We can clear these energies through our own powerful light of our being and through our own powerful mind. Aware or unaware. It is one of the higher reasons why some people travel much and to certain places.

I understood that things and places themselves carry no meaning other than the meaning we give them. They could invoke in us a certain feeling, dependent on our own individual experience, but in its origin, every place on Earth is divine. Yet, places have different energies. Places can hold energies from their past and from the common beliefs of the people who live there together, what we call collective consciousness. It can be strongly felt in urban areas. Places can feel low or high vibrational.

The Earth is mapped out with ley lines that surround the planet in exact geometric sacred patterns that are aligned to the stars and the planets. They are well known in ancient tribes and Australian Aborigines, for instance, believe they travel on these lines in their dreams. Most sacred sites of the world sit on powerful points where ley lines cross or are aligned on the same ley line. They are all interconnected by the flow of higher energy through the ley lines. Crossing points form portals to higher dimensions where ancient tribes erected stone circles and other powerful sites all over the world to tune into higher realms and to communicate with the spiritual world. There are many such sights in Scotland, and I often found out that I was moving, aware or unaware, on powerful ley lines. On the west coast of Scotland I was connected on a major ley line with the great pyramids of Giza in Egypt. They were one of my first ever visions that I had during my Kundalini awakening that randomly turned up in front of my third eye when I was sitting at the coach of my parents in front of the television in Germany some years ago. I was doing spiritual work in higher dimensions, even when I was not aware of it.

I could stay all day long outside watching the sacred processes of nature, observing how everything is interconnected, and absorbing the divine energy of the Earth. Scotland's breathtaking untouched nature and dramatic landscapes often made me feel completely in awe of Creation's perfection. Nature is my greatest teacher. My greatest inspiration. It is Creation itself and it teaches us everything if we take the time to look and learn from her.

Out there in the wilderness, I feel incredibly free and happy. I do not feel very well when I am surrounded by concrete and fences for too long. I need light, oxygen and inspiration. Earth is my holy playground, and there is nothing more beautiful than nature. She is the greatest artist.

Humanity these days has lost sight of nature, of our Mother, our origin. This unawareness has led to destruction, exploitation and imbalance with the planet, which can be witnessed in many natural catastrophes, extinction of animal species, humanity's disorientation and illnesses. These days the majority of mankind lives in urban areas. Mankind has lost the connection to the planet by cutting itself off in the cities and through lifestyles out of touch with the planet. Nature is our natural home. The city is not. Urbanization is only a very recent and very unhealthy phenomenon in human history.

When we do not value and love our planet, our connection becomes totally out of balance, as we can see by the current state of the Earth and humanity. She gives us a home, air to breathe, food to eat, water to drink and all the beauty and magic of the world for free. We must finally treat her with gratitude and kindness again instead of exploiting and abusing her.

A life in tune with nature is crucial to stay healthy in body and mind. It makes you happy and live life more intensively and intentionally. There are endless possibilities outside of urban life. Many different kinds of communities around the world that live independently and in touch with nature are constantly growing in numbers. There are millions of people that already follow alternative ways of life. They live on boats, farms and mobile homes. Some people restore abandoned villages that exist in overabundance. Many people share food, houses, passions, integrity, respect and love. Individuality and togetherness is the key. Freedom, love and joy of life.

Communities with new concepts of life do not need to separate themselves from the rest of the world. This is not about hippie or society dropout romance. The key is to interact with society and your direct environment. To be the new society. Through interesting projects like wholesome self-grown food, new forms of healing, learning and various attractions like handcrafts, music, arts and whatever your passions may be. There is enough space out there for everybody. Earth is abundant, and life is so much more beautiful in the country. There are endless possibilities. Community, creativity, independence, self-realisation and self-sustainability in touch with our planet are the future. Living in the city does not lie in our nature. Leave the concrete prison if you can. If you want to, you always can.

IV. The City is a *Funny* Place

The world in lockdown. Empty streets and squares belonging to the free birds and a few wandering heros again. What did your society and culture teach you other than to function perfectly from within a system?

P a u s e.

B r e a t h e.

Can you see the beauty and the magic of the world again?

Reclaim Your Freedom.

Reclaim Your Happiness.

Reclaim Your World.

I spent many years of my life in cities, beautiful and ugly, in bad times and good. The older I grew, the unhappier I became in the city, often without knowing why. The city's distractions did not satisfy me anymore, not because I got older, but because I was getting more and more in tune with my true self and my soul. The city repulsed me.

City habits—like going out, partying, and consuming—left an empty feeling inside of me more and more. When I awoke, the city felt like a truly hostile place. I saw how people did not care about each other and how they acted the same way every day, numb, like programmed cogs in a big machinery. Many people in the city told me they thought they had no choice, that they had to work at a job they hated to pay for their bills and houses, and that was the way life was—what a big illusion.

The more I awoke, the less sense city life made to me. I felt no joy in living in a tiny apartment, and all I saw when I left to go outside were shops and places to spend my money and consume. I do not enjoy a solely material world. There is something artificial about it; something that society offers that makes me the opposite of happy. Making and spending money doesn't inspire or satisfy me. The city sometimes made me feel as if I were in a circus, a concrete jungle, or a prison in which I didn't feel free.

Many people move to cities and surround themselves with things and people because they are afraid of the void, the silence, the nothing. Through constant distraction—and not only in the city—people do not have to face themselves or make healthy, conscious decisions about themselves and their lives. You get lethargic and passive in a world in which everything is already prepared for you, and you feel safe in your everyday routines. That is not real life. Do you not want to create a life for yourself? Where did your inspiration go, all you ever wanted to become and do when you were a child? Do you remember? Your dreams were always meant to come true. This is why we have them.

The city is a constructed world of the state in power, and society and culture is there to make you function in your role. It is a lifestyle imposed upon us that we often did not consciously chose for ourselves. It was already there, and we were programmed into it from a very early age. Most people never dare question the status quo because it would shake their worlds. People are afraid of change, but life is all about change. Life never stands still.

Many cities are soulless places that cut you off from Mother Nature, Creation, and your spiritual self. When I walk in nature, I feel the consciousness of every single plant and rock. I feel a Oneness. I am at home in myself and connected to everything that exists. I feel powerful, healthy, happy, calm, grounded and in peace and balance. These are the true effects of nature on us, which is lacking in the city.

We need to breathe in healthy air and connect to spirit, and we do not get enough chances to do this in urban life. City life often does not give you enough space to be in-tune with your spiritual side, your true self, through the constant distractions and massive overstimulation through the neverending obligation to succeed in the system. Your spiritual self needs time to process, heal, integrate, align, and connect to nature and your inner-self, or we lose ourselves, fall out of balance, and become ill.

To be awake, we need to wander in the daylight and breathe in oxygen. Light contains information and walking around in nature grounds you so you can see the bigger picture and bring things into perspective. If you spend too much time in houses or cities, it is easy to feel depressed because you lacked light, oxygen, exercise, inspiration, and contact with Creation.

City life does not lie in our spiritual natures. Making and spending money is not the meaning of life. It can be fun sometimes, and some cities do have some wonderful

things to offer, but consumption must not be a justification or raison d' être for city life. It has been proven that people growing up in the country are at a lower risk of developing physical and mental health issues in adult life, and they are generally happier. We must live in touch and get into balance with Mother Earth again instead of cutting ourselves off from her.

Many cities have become places of death, where people merely exist instead of living life. They hang around in their tiny concrete boxes that some only leave to shop or walk the same block for half a lifetime. Monotony from your daily routines, work, and watching TV shows slowly numb you to the point at which you risk losing every sense and sensibility; it is time to wake up now.

You see many people with miserable faces on the streets of the city, stuck together in a tiny area without ever greeting, valuing, or recognising each other. Many seem stressed out, anxious, or unhappy. Often, there is no sense of community, joy, or friendliness. There is an huge amount of places of consumption that are disproportionate to what is needed. It is a money-based world. When I leave my house, I want peace and inspiration instead of smog, noise, and annoying shop windows.

It is human nature to wander around and explore the world, but our system encourages the opposite by enslaving us to materialism and consumption. It makes many people feel so bound to their place and lives that they are afraid and do not know how to leave their comfort zones and forget how to live life instead of how to function in a small system. All you need is to find your willpower that many people seem to have lost by being overly restricted and programmed by society and culture's established norms and framework of life.

We are made to feel much smaller than we are, pressed into tiny boxes, going totally against our unlimited natures. Break out of this cage. Plug out of this passiveness and lethargy. Wake up from the slumber. Step out of the unhappy passive collective consciousness of the old world. It is time for action. Rise above it. Stand up and say, I've had enough!' You have the power to change your life. You can do whatever you wish. You have free will.

Handing over the keys from the old flat I had in the city in the country where I was born marked a great event in my life. I felt that every cord I had tethering me to the old system had finally been cut. Until the very last minute, I felt suppressed, having the feeling of only being a spoke in the wheel that keeps the machinery of money running. Neighbours who never spoke a word to me filmed and photographed my moving out, examining what I put in the bin, afraid I would take their space in it. I lived in a system in which people locked their bins and put signs on houses saying, 'Forbidden to lean bicycle against the wall,' and there was much more and worse than that. Through excess regulations, restrictions, and laws, many people have become so anxious and small-minded that they are not mentally well, which probably explains why you see psychiatric practices on every street corner. No, there is nothing wrong with you. You do not need to be made to believe in an illness you do not have. All you need is to get your life back into your hands.

It is dirty underneath the polished facade of a system where everything seems perfectly organised, and all well-praised social benefits come with a price: the loss of Freedom. It is something that many don't see because people are blinded by money and trapped in the illusion of 'social safety'. I am proud to say that I was a rebel. I always spoke my mind, and I always followed my heart. No power over me. No power over you. Power to the people!

V. Going With the Flow

Spread your wings and let the wind carry you to the most wondrous destination of your dreams

My leap of faith was all about trust and growing faith. When I lost everything I ever owned, my faith was all I had left, and it was all that was keeping me alive. With time, I understood that I had written the very best script for my life. I had chosen this great adventure road trip life, pre-birth. We map out important stations in our lives and what we wish to learn before we incarnate on Earth, and I had chosen to go through both extremes, to go through the greatest pain to experience the greatest bliss, from heaven to hell and back to heaven.

I have liberated myself. This path is my highest spiritual learning and evolution and worth more than any degree, money, or wealth in the world. To be free.

There were many times I had zero security and stability left, and I had no idea where my path would lead me next. This is how I learned to be at home everywhere, fully trusting the flow, and living in the moment and in my heart. This is when the next steps of my journey always unfolded themselves in all their magic and it was one of my greatest learnings: not knowing, trusting and going with the flow.

Pieces of the puzzle of my life made a greater picture every time. I started to see that I had manifested all of these wonderful steps on my own, and I understood that everything in my life I had ever experienced and every moment was perfect. Sometimes, I would not see where all the steps would lead me until much later, why certain things happened, and others didn't, how I miraculously seemed to always walk in the right direction, even if I did not always know why I was heading that way. I listen to my intuition and inner-guide, that never leads me astray. Never doubt the path of your heart. Never doubt your soul's path, even when nobody around you believes in you. Always believe in yourself.

Eventually, I saw that this was not about the destination but the journey. Every step of it was exactly the way it is supposed to be. Everything and everyone on our paths are interwoven in divine timing and purpose.

Once you give up all of your fears and limiting beliefs, your worries about the future and grief about the past, once you build faith in yourself and the Universe, you will eventually learn to go with the $f\ l\ o\ w$. You are riding the waves, deeply immersed and present in every moment. This is living on the edge, at times. It is the real-life experience. It is the crazy, epic life. Other times, it is like floating on a soft cloud, like in heaven. Life this way becomes an endless adventure full of magic and surprises behind every corner of every street you travel.

I have hitchhiked a lot. You need complete faith, and the outcome is always open, yet I always managed to go where I wanted to go. How? I focused on my intention and destination. I always met lovely local folks who sometimes invited me into their houses for tea or to stay at night. Some drove me where I wanted to go, even if it was in the opposite direction. I had many special encounters that I will never forget. People welcomed me with open hearts and minds because my own heart and mind were wide open. I grew much faith, strength, bravery, and a lot of experience on these trips. Of course, I could not just stand by the side of the road, dreaming away. I knew I had to be present and vigilant so I didn't get into the wrong car with an untrustworthy person. I always applied my common sense and all of my intuition on which I could perfectly rely. I live at a high vibration and not in fear and worry, and I always practise to be at zero-point-consciousness. With time, I became a real master at manifestation through focus. I managed to go wherever and whenever I wanted by hitchhiking, even in the most remote places, much to the surprise of many people. I love that way of travelling. It is fun and exciting. To me, it felt so much better than some luxury trips where everything is already planned out – how boring. I don't like to plan too much. I love spontaneity.

Why don't I like plans? It's because the future and linear time does not exist. All times exist simultaneously. I had heard of this before but only believed it when I experienced it myself through time-lapses, time travel, and out-of-body experiences. Once, I remembered the future. I jumped from the present into the future and back, and I saw my book already published. Another time, I experienced the exact same thing twice in a row, and it blew my mind.

It is possible to travel to the past and to the future with our consciousnesses. Time travel is shifting dimensions. If we want, we can experience the past again in the present. Nevertheless, I prefer to value and let go of my past. I create my future in the present. The present is all I have.

Through the active consciousness and mental and emotional processing of my past practising healing, understanding, and forgiving, I cut all vibrational cords to my past. This way, I am energetically, mentally, and physically entirely in the present moment. Living in the moment is a choice like everything else is.

In the present moment, I can create whatever I wish. There is no remorse, no grief, and no frustration related to my past. I am aware that I have attracted everything I have ever experienced in my life through my own vibration. Everything happens in perfect timing. Everything I experience is for my growth, learning, and enjoyment.

I choose not to live in the past because I cannot change the past. I do not wish to waste my energy and time. If I live in the past, I will lose the present moment. The present moment is all I have to live my life to the fullest. I do not live in the future because the future does not yet exist. Wishing or planning too much about your future contributes to an energy of lack, and it blocks the energy to receiving what you wish to have. Missing and expecting nothing attracts everything. This is the law of attraction.

Where I am standing at this present moment is a consequence of my past. I can only move forward, though everything moves constantly and nothing ever stands still. Do not imprison yourself in a mental cage of how the world, your day, or your future has to be, but take the moments as they come and make the best of them.

There are endless possibilities in every moment and in your life that will open up for you if you do not focus as much on the outcome or the future of your life, and when you live in the vibration of the now and have an awareness and feeling of your inner-abundance. Too much planning limits the endless possibilities from which the best will unfold for you according to your vibration.

Embrace the moment; it is perfect. Everything else will come to you in perfect timing. I am abundant in this very present moment, yet I can focus on what I wish to create in the future through wise beliefs, choices, actions, and intentions. Finding that balance, the golden middle of making and letting things happen is the key.

Some stages of my life were like a road movie, and I knew that planning would not work for me, and I had to surrender to the flow. Before my life could unfold in all of its magic and adventures, I had to grow faith in myself and the Universe. I knew that all that ever happened was a reflection of my own vibration. I live a freestyle life, but it is not the life of an outsider who lives on a beach separate from the rest of the world. I am in the world, sometimes by myself and at other times amongst people, and I enjoy different facets of life and life in its complexity. I love the lifestyle of endless summer on a beach and travelling around in my camper van and of course travelling and exploring the entire world, moving from place to place, living in many different places and settling in divine timing. Sometimes I spend valuable time with family and friends. I take on

jobs when I feel like it; they come to me and they align with my values. Sometimes, I like doing nothing at all. I like writing, playing music and singing. I like doing a good mixture of both practical and creative things, using my head and my hands. I liked washing dishes in a busy Scottish pub as much as being a private teacher for the Russian government and it is important to take part and enjoy everyday life at times. In fact, the job in the pub was much more fun, even though I earned a tiny fraction of my Russian salary whereas in Russia I saw and learned many different things. It is all about learning and expanding, having fun, living life, and feeling good.

Photography

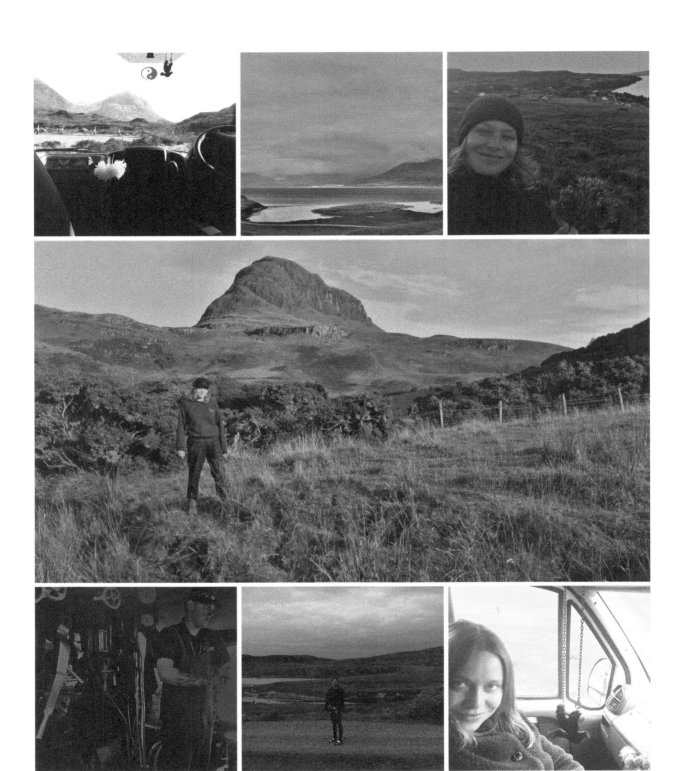

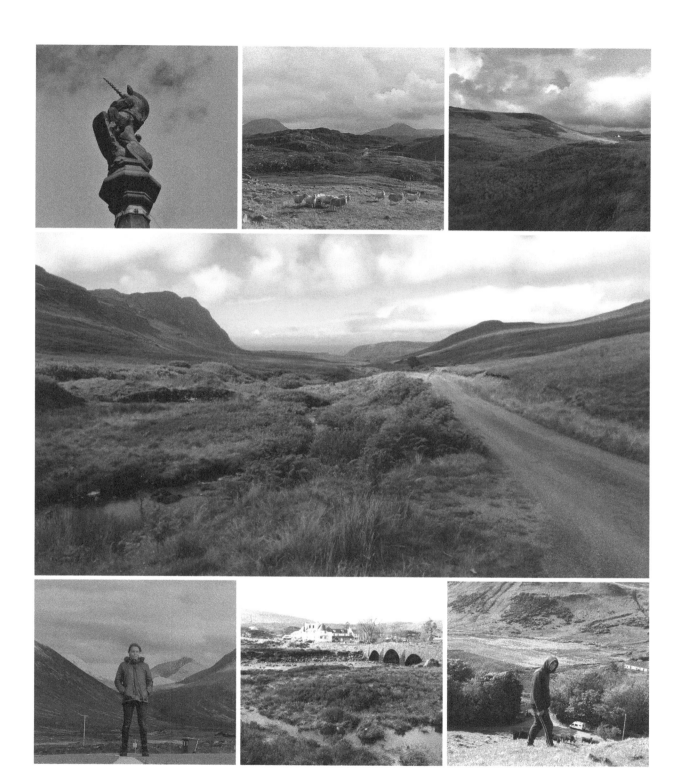

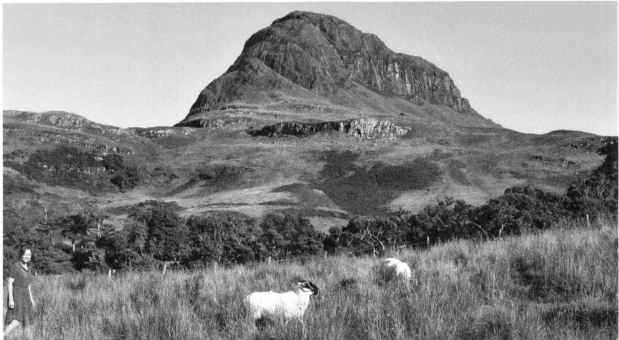

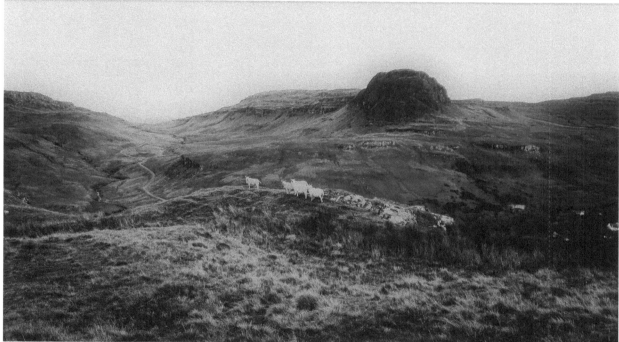

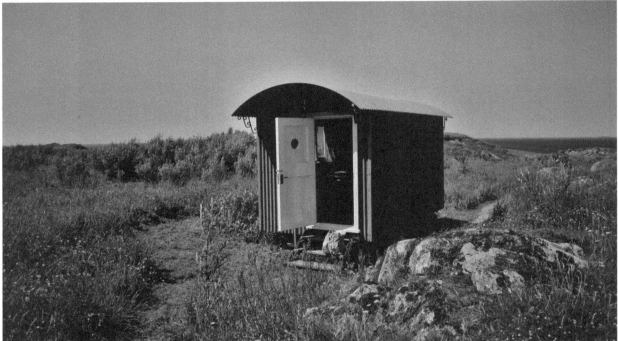

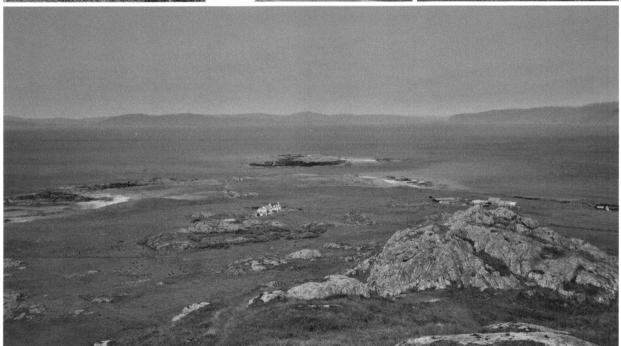

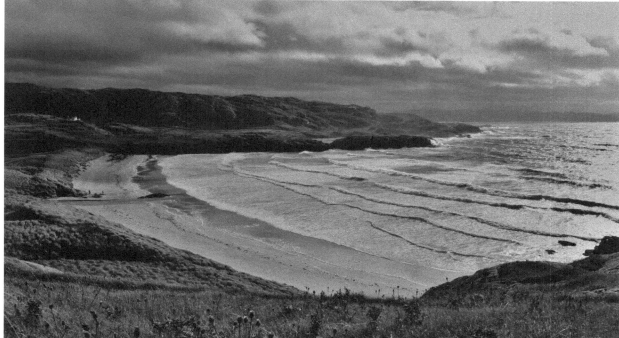

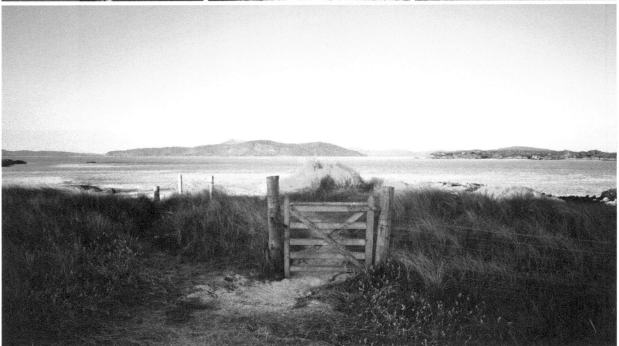

The Talisker Dream

I flew down the long, windy, bumpy road to Talisker. Lush, flowering, yellow gorse bushes lined the way, sheep fleeing to the left and right, clouds dancing in the blue sky. Below lay the majestic blue sea. It was a beautiful day in May and my favourite month, but time did not exist anymore. I wanted to love him and the land, here and now, because I knew the dream could be over tomorrow; we never know this. There was nothing to fear to lose but the present moment. This was all I had, and it was perfect.

I parked my van at the gate of his house. He came slurping towards me with his mischievous grin. 'We're pulling my van out of the field up there,' he said. I smiled. How had that happened?

'Just parked it there to lay in the sun, and then I got stuck.'

'Okay,' I said. 'I'll see you in one hour, here.' I climbed up the steep hill and found a nice spot in the soft grass from where I could overlook the entire glen (Scottish: valley). I was surrounded by green highland hills as far as I could see, dotted with a few sheep. The windy road down to the bay that looked like a nearly invisible thin thread of string divided the great glen right in the middle. There was not a soul, far and wide, only a father and his son who tried to pull the van out of the field with a Landrover. My eyes went round the glen. It was open, green, spacious, and with a golden glimmer that filled the air. Streams of the clearest water came running down the slopes, making pretty pools and waterfalls where birds liked to gather. A few large rocks decorated the whole scenery. Wow, what a place, I thought. Heaven on Earth.

It was surreal, and I felt as if in a dream, the most peaceful and beautiful place I had ever seen, a sacred place where wild orchids grow. It was my favourite place in the world, and I love it beyond words can tell.

One hour later, after they had pulled out the van of the field, we looked at each other and decided to go up the hill together. He was covered in mud, and I liked it. When I looked at him, I dreamt about loving him in the sunny, green, soft hills, and maybe we shared the same dream. There were just us, the sheep, and the angels. We were in paradise. Together, alone, and One with the world.

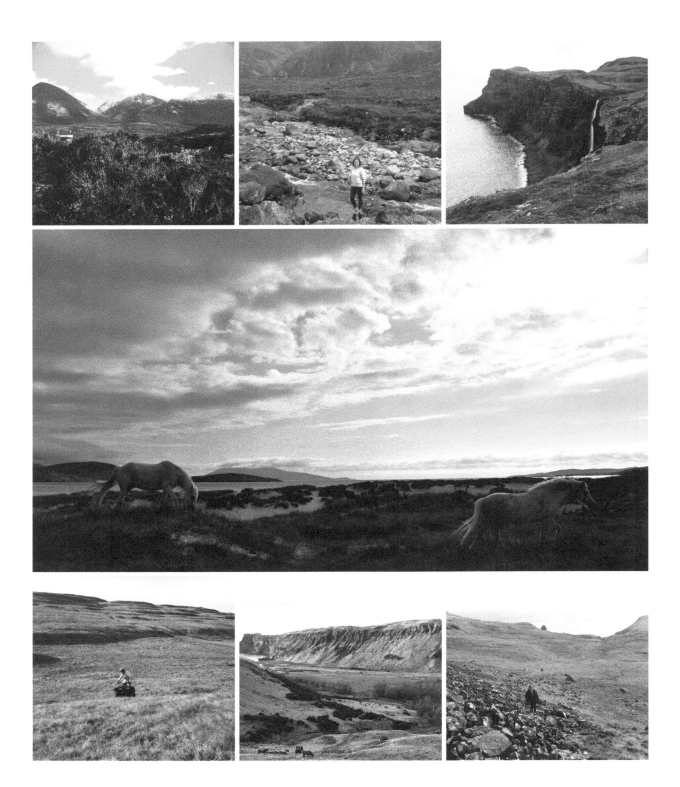

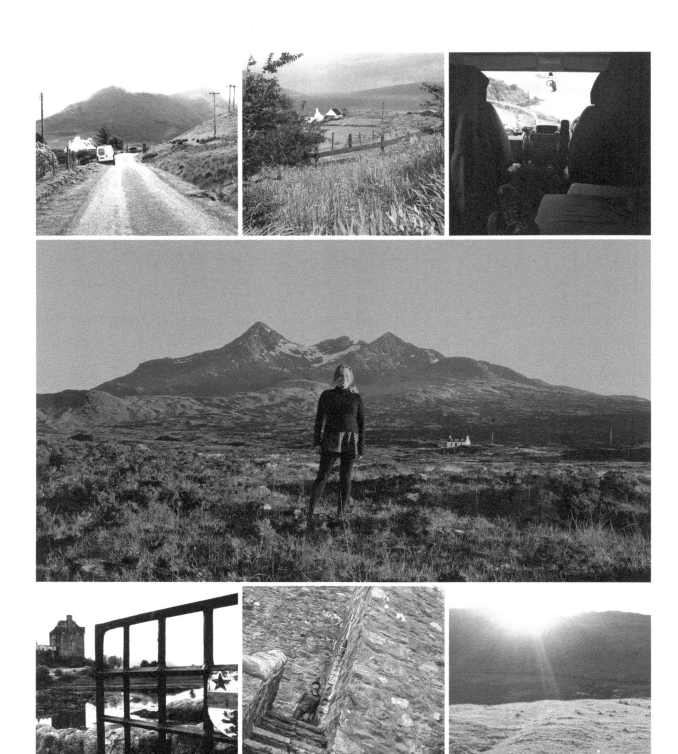

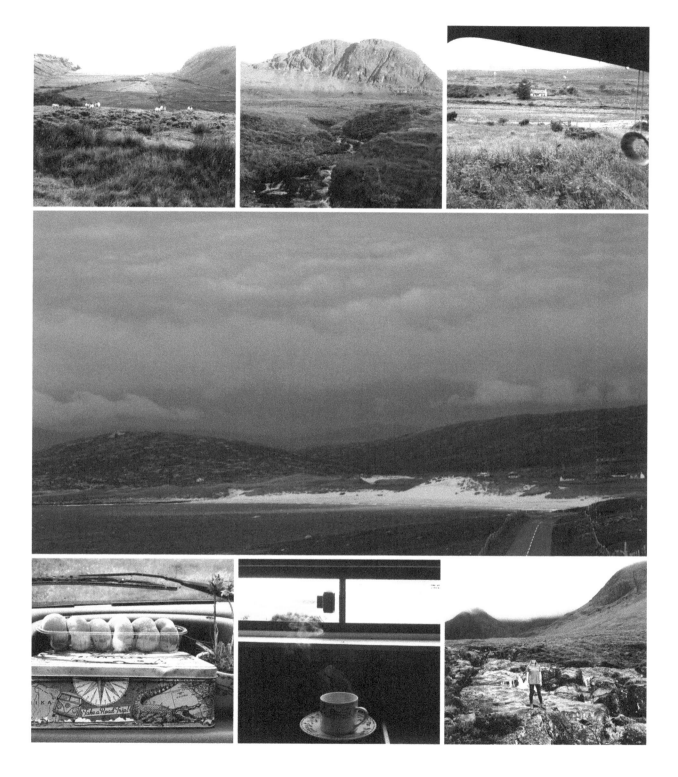

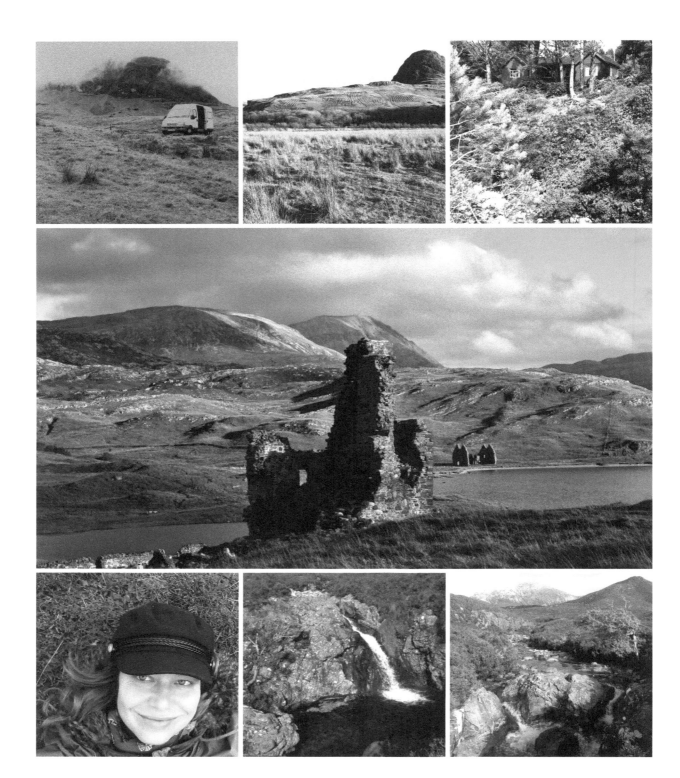

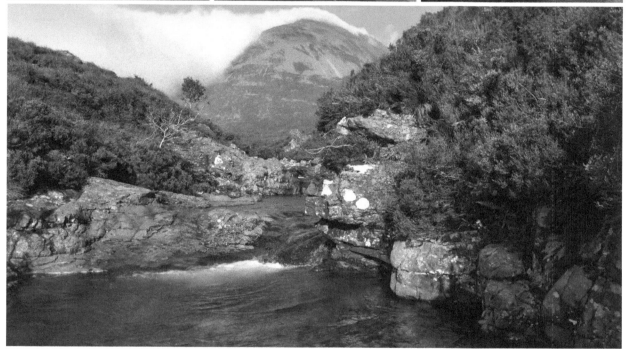

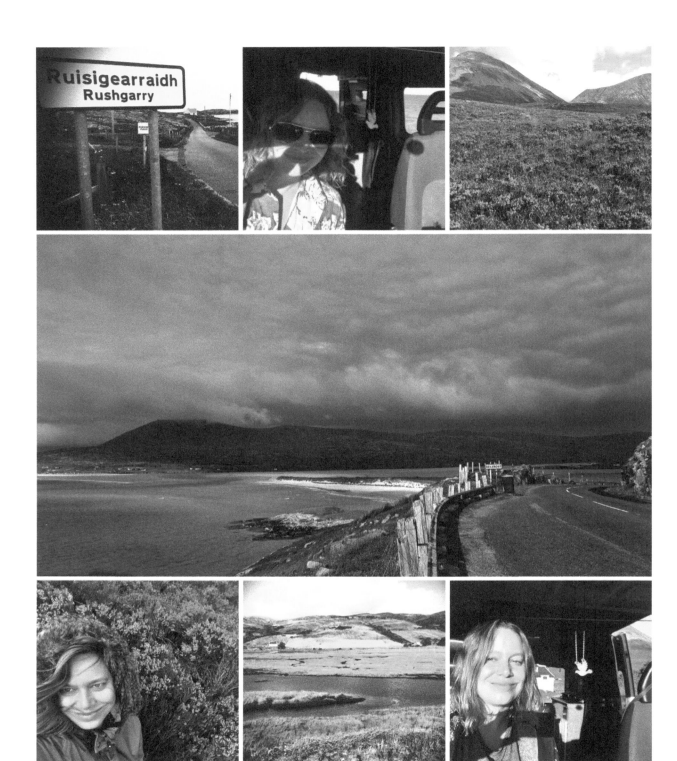

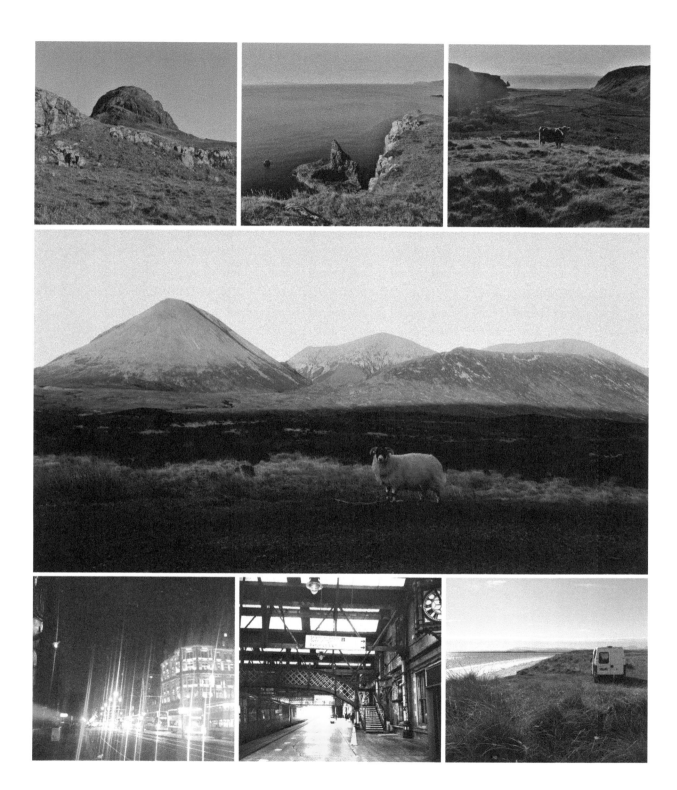

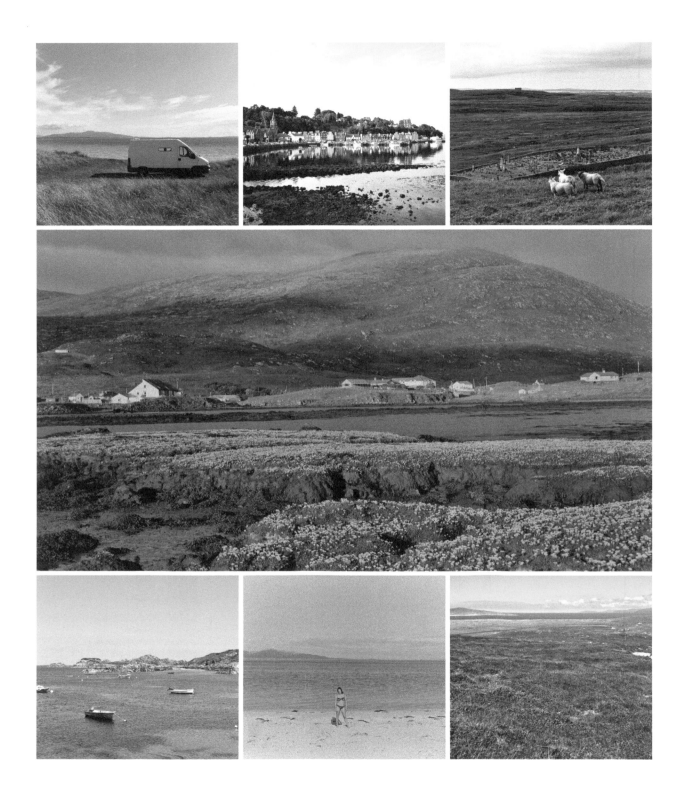

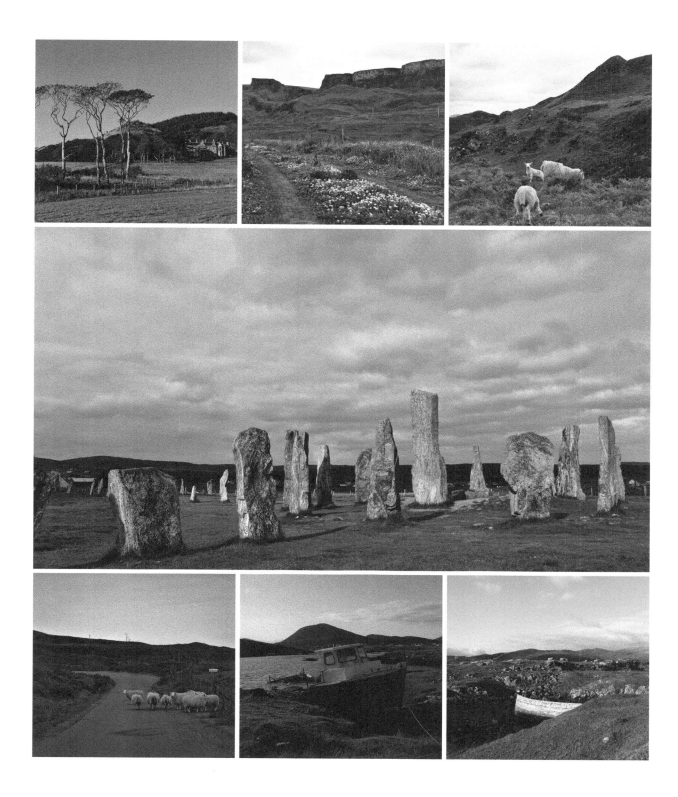

VI. I Am Who I Am and I Do What I Want

.

This is me
My name is Janet
I must not conform
Not fit into

f m

o

r

I must be myself
Otherwise, I am half alive

Why would I let my life be determined by the norms of society and culture or anybody but myself?

I am not impressed with old-age pensions, life insurances, 40-hour work weeks, or any other reward or benefit of the system because, in truth, it makes me a slave of the system. I don't let money imprison me. All of these models for the working class hero take up way too much space in our lives. There are other, better ways.

People hide the unhealthy effects of these lifestyles by putting on their nice make-up, together with the nicest smiles every day. Many escape into drugs and alcohol. In which society do we live, where pain killers and sleeping tablets are advertised as something normal? It is not!

The time is here, now, to question and modify our ways of life. There is no work-life balance in our society and culture. Many people work so much and so hard in their lives that they get mentally and physically ill. 'Modern slavery' must end! There are endless, alternative ways to make a living, be free, and have fun. If you still believe this is impossible, it is your choice and your limiting belief and therefore your reality.

I have tried out many different lifestyles: working like a dog, not working at all, working sometimes, and working part-time. I worked in the most hated jobs and the most highly regarded ones. I was self-employed, and I worked for the government, privately and unofficially. I worked in farms and fabrics, pubs and hotels, in shops and offices, schools and institutions. I have learnt countless things and will continue to do so. After all, I have found my own independent, happy way of life. I do what I love, when I want and how things come to me. I go with the flow and I stick to my values and to my freedom.

Anybody can leave the machinery of money behind if they want to. All they need is willpower. I have had money and no money at all in my life, and to be honest, it did not affect how happy I was. Even during times with little money, I was often happier because I didn't have a job that I didn't like. I do not wish to do the same boring thing day after day, wasting my precious time away. When I sometimes choose to work hard, it is of my own free choice. This is why it is all right. I do what I want. This is my right.

Unfortunately, we are so strongly programmed into wanting a professional life and identifying too much with our job, status, and belongings from very early. We need much less money than we are made to believe. Identification with externals only such as money and professions is not sane. A job should simply be there as a means to an end. It should be fun in the first place. It must never consume your entire life. Unless it is your greatest passion.

We are constantly programmed by society's norms, common beliefs, our own limiting beliefs, the educational system, the media, what our parents taught us, and all that we hear outside. Don't be the result of something you are not. You are far more than that. Paradigms of society and culture are artificial concepts that are all limited and something you do not make up on your own. They are beliefs you pick up from outside of you that form who you are. Now is the time to break out, to break the frame. We are unlimited, spiritual, powerful, eternal beings who can create whatever we wish, and it is time to live our best lives, the lives of our dreams and not the lives of others. Don't live a life that is based on others' beliefs, opinions, expectations, and limits. Live your own life, and live it without limits.

I do not have to do what society tells me. I make my own decisions. I take full responsibility for my life. We are made to believe that things have to be in a certain way, but who determines these ways? Don't let rigid concepts or anyone else limit

your life. To believe we have to suffer and work hard in this life, work 40 hours a week to achieve something, is an illusion. I do not believe this anymore, and I do not live like this anymore. According to the law of attraction, we attract abundance into our lives as a reflection of our beliefs and vibrations.

I did not have to work 40 hours a week, 12 months a year anymore. It was not fun and not healthy, so I stopped doing it. When I did do it, I often felt like a machine. I lost myself, felt out of balance, and became unhappy. There was no time to breathe, to meditate, no time to connect to spirit, no time to look around to see the beauty of the world, no time to do the things I loved and wanted, no time to process my inner-feelings and experiences, a process so crucial for our emotional, mental, and physical wellbeings. We need to have time for ourselves, stay in tune with our spiritual sides, stay connected to all that is, stay at a high vibration through the constant process of clearing and activating our chakras.

I am not a slave to the system, and I am not a machine. I want to be independent, free, and happy. I rely on my creative skills and natural and practical gifts; this is why we have them. Everybody has something at which they are good. You should live that way and invest in it. Live your passions!

You have to love your job or love what you do. I have a university degree in teaching. Teaching is my passion, but I chose not to work in public schools anymore a few years ago. Sometimes, I teach in alternative ways, instead, because I do not approve of the educational system that is one of indoctrination, power, control, hierarchy, segregation, and classification. I would rather live without a big school teacher's salary and 'safety' and without all of the other financial benefits than conform to something I do not like. I do not struggle with money because I do not worry, and this is how I always have enough and even more, or unexpected money comes to me, but most importantly, I do

what I love. My life unfolds with ease because I do not believe in hardship anymore. It is the law of attraction. One of the great secrets. Yet, I have often worked hard to achieve what I wanted and it all serves my learning and growth.

Life does not happen to you. You make it happen. When you have the feeling that life happens to you, you might feel like a victim of your circumstances or lost in self-pity, and you are not standing in your power. What we attract into our lives is a reflection of our vibrations, consciousnesses, and beliefs. Rise up and create what you wish. It is your life.

I do what I want from my heart and with my willpower. I can do whatever I wish, and no belief can ever limit me or make me believe the opposite. I am free. Whenever something does not feel good or right, I change it. I change my situation through my actions, or I remove the limiting beliefs if I have them.

When we start to remove all limiting and false beliefs of who we thought we were and who we were told to be, we can sometimes fall into an inner-void of fear, not knowing who we are. Remember that every fear is an illusion, and it makes you stronger once you overcome it. You overcome fear through a deep faith in your heart. You can never be lost. You will always find yourself again.

You will eventually come to a profound realisation and self-awareness of who you really are. You will feel greatly empowered through the embodiment of your higher self, your true self that can only come to you when you open your chakras by removing all fears and limiting beliefs. This is how you embody all aspects of your soul and become whole. You will come to understand that it is neither necessary nor possible to find words to explain who you are. You are a spiritual, infinite soul. The being of light

that we all are can hardly be described in human language because human language is limited. I am who I am. I am everything.

I can only be limited in the perception or description of a person with a limiting belief system who will limit and classify me to fit into the world that exists in their mind. My unlimitedness cannot be comprehended within a limited mind. Pigeonhole thinking or classification is not the correct way to describe an unlimited soul. Human beings have the need to put everything into words and order – it is because of how we fit into form and matter, but our unlimited souls exist beyond our physical frames. We have no limits. It really does not matter what others think of you.

Everybody perceives a different version of yourself according to their beliefs and experiences, yet I am who I am. When you reach the point at which you no longer judge anyone or anything because you are free from limiting beliefs, you will be closer to zero-point-consciousness, where you exist in the very present moment without judging or believing, where everything just is, where everything is perfect the way it is. You will have become an observer.

Whenever other people trigger feelings other than love and peace in me, I am being shown my limiting beliefs or signals upon which I should reflect because only I can experience what I am. This interconnection between us happens since we all come from the same source, and we are all one. I recognise myself in the eye of the other. I am you, and you are me. I am your mirror.

True love is a reflection of yourself – the person you love – in your mirror. Attachment, codependency, admiration, and obsession are things that often get mistaken for true love. True love is free and eternal and cannot be owned.

What we love, we cannot own. Love cannot be put into a box. True love penetrates everything and tears down every wall.

We can only experience the aspects we carry in ourselves that are mirrored back to us. True love is the recognition of your soul in your mirror. It is often experienced with soulmates and twin flames that share the same soul-blueprint and that are here to remind us of who we truly are and trigger our spiritual growth and expansion.

Many people lack self-love due to false and limiting beliefs about themselves, as well as pain and wounds from their pasts. These can date back to early childhood or previous lifetimes. If you manage to heal your wounds, release your limiting beliefs and your ego, align with the vibration of the Universe that is love, open and activate your chakras, discover and find yourself, and you will come to love yourself.

The more you love yourself, the more you will love others. What you see on the outside is a reflection of yourself. You attract what you reflect. When you are sad or feeling frustrated or unhappy, your entire world is unhappy. When you are happy, you can embrace the entire world and experience the same world as a happy one. This is how your world depends on your vibration and how your reality switches depending on your energy, consciousness, and beliefs. Everything we perceive outside of ourselves is a reflection of our frequencies.

We attract people with similar vibrations to our own life according to the law of attraction. People leave our lives when we are no longer on the same vibrational levels, or our lessons together have been fulfilled.

'I do what I want' is an active choice made from the awareness of my free will that comes from the heart after all limiting beliefs of the ego have been dissolved. This

process activates a great power within you. Together with your unshakable belief to be able to do what you want, you can make anything happen. These processes within your consciousness lead to the full activation of your chakras, your energy centres. With your solar plexus and sacral and root chakra fully activated, you will have the power to do what you want. Anything becomes possible. With your upper-chakras activated, you can channel cosmic knowledge and embody your Higher Self and live in the unlimitedness.

The world must know this. The long lost knowledge of how we stand in our greatest power when our energies flow through us freely must no longer be a mystery. Illnesses come from false beliefs, blocked energy, unhealed fear, trauma, and pain, and limiting beliefs that lower your vibration, close your chakras, and weaken your immune system. When you have released all of them and are attuned to love, the vibration of the Universe and living in Oneness with all that comes with a healthy, happy way of life, you will most likely never get ill.

What made me empowered, too, I realized much later, was the balance of my inner-Yin and Yang, the mastery of my energies within. We all carry masculine and feminine energies inside of us. If they are out of balance, if you have too much masculine or feminine energies, you can lack action and rationality or the feminine aspects of intuition and empathy. It is one of the highest levels of mastery to balance these polar but completing male and female energies. Balance the aspects of flow and action, surrender and power, reason and emotion. When you find the golden middle, you will stand within your greatest power, your full, empowered self, your divine Union within, the long-lost secret revealed to you.

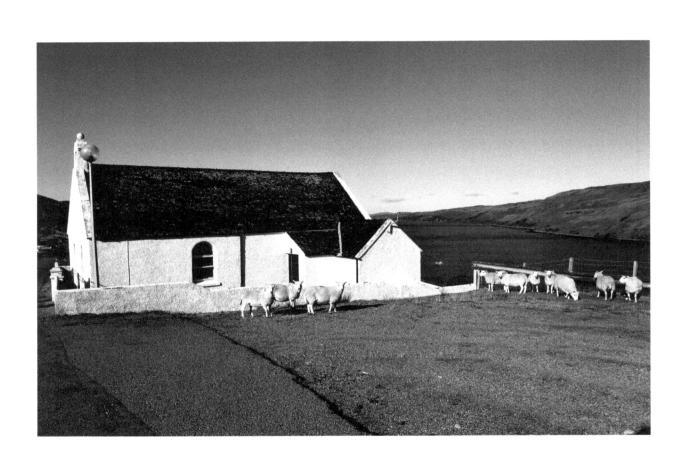

VII. Who is God?

You don't find God in scripture.
You find him inside your heart first, and then in all other things and people.

It happened when I was in the deepest darkness, experiencing the greatest fear and pain in which I had ever found myself after I had lost everything and when I was struggling to survive. It was then that I was, all of a sudden, embraced by the brightest light and the deepest love that one could feel. It was an energy that penetrated each and every cell of my body and immediately stopped my pain. It lit me up and made me feel love in its truest form. It saved my life when I was afraid to lose it. I believe that I was opening up to my inner-white light that broke through. Back then, I was sure I had met God. They say one must break to become enlightened, and that was my experience. The surface must crack open for the light to come in or go out.

I remember the day I found myself in the very deep, western corner of the south of Ireland after an adventurous trip of hikes on one of my backpacking pilgrimages, searching for the truth. Today, I know I was searching for myself and for whom I believed God to be without knowing it. I had gone far away from everything. I felt as if I were at the end of the world when I sat on the shore of the wild Atlantic Ocean's west coast. Questions arose inside me as to why I had gone there and what I was actually doing. The fear of primordial survival overcame me when I looked around into the nothingness. I felt alone and lost. I struggled to breathe, and when I instinctively let go of my fear, it happened. When I finally surrendered to the now, I felt and saw God in every little stone and sand grain, in the gentle waves, the hills, the birds, and in everything that surrounded me. I was overcome by a profound feeling of love that arose from deep inside my heart, and I saw love in everything. This is how I fully grasped that I and everything else is made of love, that everything is interconnected, that love is all there is, and I was never lost again.

I started to speak to God, but the more I evolved on my spiritual journey, the less I was able to connect to God outside of myself, and I could not feel God anymore outside of myself the more I released the illusion of separation within my consciousness. Something profound had changed. I realised that I was not separate from God, and

that I could not refer to God as being outside of me anymore. I felt God inside of me. From that moment on, I knew we were the same. We are One.

One of the greatest lies we have ever been told is that God exists outside of us. We all come from the same source. If we all originate from one source, then we are all a part of that source. We all form that source. We are all that source. We are nothing different than the Source is. We have co-created this world and everything else we have experienced together. You are God. I am God. We are God. We are One. You cannot understand this in the mind—you can only feel it in the heart.

These days, I experience Oneness and love most of the time due to my expanded consciousness and living at a high vibration of Oneness. It makes you understand that there is no separation, that good and bad are just a game, that Yin and Yang, light and the dark, the moon and the sun make One. Everything serves the light. Stars can only shine in the dark.

Love is the greatest force in the Universe. I awoke through true love. Love is what broke me up from the inside out to let all of the truth and light in or out. It broke me up like a shell and aligned me with the vibration of the Universe, which is love, in a process in which I had to release every thought, belief, and chord that was not aligned with love or that was an illusion. Love is what enlightens us and makes us find our true, godly selves. I experience love and God in everything because I am love and God. You can call it God, the Source, the origin, all that is, Oneness...it does not matter what we call it. We are all searching for the same.

Everything I experience is a reflection of myself, and I can only experience and feel what is a part of me. This makes me understand that the love and Oneness I see outside of me is a reflection of my vibration, of me being love, and living at a high vibration of love where no separation exists. The lower I go in vibration, the more separation I feel, so the

mastery is to live with your feet grounded on Mother Earth and your expanded mind attuned to love. Do not fly too high, forgetting to ground yourself in the here and now. The mastery is to bring your light, your full awareness and focus, and your higher-self inside your body and to the ground. Choose to stand here and now in your full glory and enjoy every precious moment.

Today, with all of my chakras fully opened and activated, I get headaches due to blockages in the flow of my energy from ideas or beliefs in separation. My body has so upgraded and become a body of light that it immediately detects every untruth and illusion through the guidance system of my feelings. At birth, we are given this incredible emotional body that always tells us what feels right and wrong. Everything that does not feel right is untrue and can be released from your system of beliefs.

We are given free will to experience the entire possible spectrum of experiences from hell to heaven for us to discover, through our own godly, creative, self-realisation, that only love is real, to come to the conclusion of what is right and wrong ourselves and to make our own choices.

We live in a society where we are constantly encouraged to look and search outside of ourselves. We have idols, guides, and heroes, trends, and social media on which we compete and compare with others. The outside plays a greater role than the inside, our truth, our inner morals, our values, and our wisdom. We all have this in our hearts.

To find ourselves, we must look within, to find out who we really are, to find out that we are God ourselves. Everybody is, in his/her uniqueness and individuality, yet we are all the same, and we are all One, coming from the same source. Stop looking for leaders outside of you. Listen to the wind, the birds, the silence, and your inner-voice instead. This is your true guidance. You will never find your power outside of you. Your true power lies inside of you. You are your greatest power. You are God. Everybody is. You might just not remember it yet.

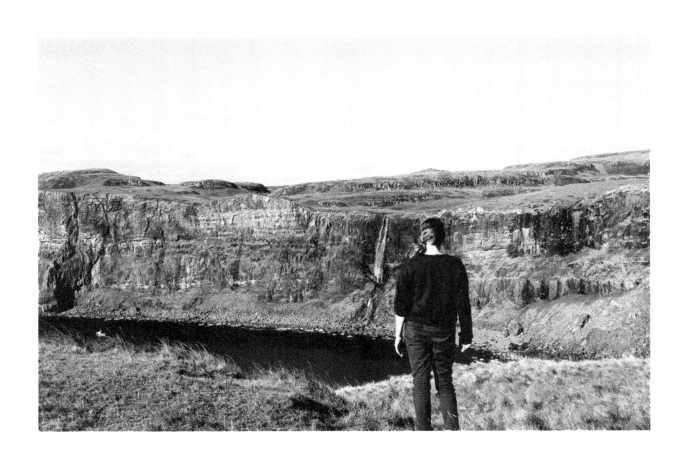

VIII. Happiness

Taste of Freedom

Gazing at the shimmer of the silver sea
that rolls gentle waves towards me
in my white sandy bay
on an island far away
from the world's load and people's concerns.
Where seagulls, seals, and dolphins are my
only company
I find myself in this perfect place and time
that fills my heart with utter bliss,
and everything makes sense like this.

We are all searching for happiness, and it means something different to every person. I was also searching for happiness I could not find in city life, parties, holidays, or any of the other things and people.

I was searching, and I did not even know it, nor did I know that for which I was searching. Today, I know that I was searching for myself, my true self. I was looking for something outside of me that could only be found inside of me. All happiness outside of you is transient. True happiness arises from within your heart. You must become your own happy person and never make your happiness dependent on other things, people, or anything else outside of you.

Happiness is Freedom. Freedom is the state of mind of an expanded consciousness that manifests in all areas of your life since your life is a reflection of your consciousness, belief system, feelings, and vibration. Freedom is a feeling in your heart.

True happiness can never be taken away from you since it lies inside of you. Become the master of your happiness and cultivate it like the most beautiful sunflower in your garden. You will find it through your discovery of self and your love of yourself which will grow into universal love, into love for all things and people with whom you will share your happiness which will make you even happier. Love will be reflected back to you. Love and happiness expand and radiate strongly, and it affects everyone around us. This is the nature of love.

We came here together as One. Sharing makes us much happier than having it all to ourselves. Nevertheless, always pay attention to having enough space for yourself. Stay true to yourself and in your own energy. Grow healthy boundaries and always be your true, authentic self, so others can see and respect you.

Living in community makes us happy. It is even better with soulmates who show up by themselves when the time is right, rather than on purpose. We all have a soul family with whom we choose to incarnate and learn in countless incarnations on Earth. The more you become your true self, the more soulmates with similar vibrations and blueprints turn up as reflections of yourself, and you will reunite and keep learning and creating together. You will immediately recognise your soulmates. You will feel very much at ease with them and have the feeling as if you have known each other for a long time. You will have this because you actually have known each other for a long time. It is beautiful to love and share, laugh and cry together with our true friends and create beautiful things together. Yet, do not be afraid to be alone. It is an important time to heal, learn and find ourselves.

To live your happiest life, you must do what you love. It is true that, sometimes, we have to do unpleasant things in our lives, but they become pleasanter when you change your limiting beliefs around them and stay in the faith that better things will be coming.

Happiness is self-realisation and living the life of your dreams. It is doing what we love no matter how many norms or voices tell you otherwise. If you cannot attract what you dream of yet, you might not have concluded, learned, or understood previous lessons. Be patient, modest, and grateful for what you have in the now. You will attract new things in the perfect timing. Yet, you can set your future intentions and never doubt the fulfillment of your dreams.

To be happy, you must follow your heart. You will recognise the path of your soul through excitement, through a sparkle in your heart, as it will come with passion and ease in its unfoldings and manifestations. This is the path you should follow instead of one of ego, consisting of beliefs based in separation, reflecting society's limiting norms or other

people's opinions of what and how to do things. It usually does not come with joy and ease like the path of your heart, but it is often with difficulty and hardship.

Ego makes us much smaller than we are, in truth. It makes us feel bad, but anything that comes from the heart never does. Learn to listen and distinguish both voices and follow the voice of your heart, that silent inner-voice, your intuition, your gut feeling. This is your soul's path and where your happiness lies. It is the path of Liberation. Do things differently. Do them in your own, unique way that the world has not seen yet. You did not come here to be a copy of others but to be your own, extraordinary, original self. You are here to do what you love and to be who you are. Enjoy your life. It is the meaning of life. Life is meant to be fun!

Happiness is living in touch with nature instead of living in a pre-programmed, urbanized world and system where your whole life revolves around how much you have to earn to pay your bills, or how, what, and when things have to be done. Conformity is terrible, and perfection is boring. You are a free, sovereign being. Make your own choices and decisions. How can anybody else know what is best for you? Be open to listening to the voice of others without prejudice but always with discernment. Treat everybody equally because everyone is equal. Do not judge. Listen carefully. You learn from others as much as they learn from you. We are always learning together.

I do not feel well when I am locked up inside houses, offices, or cities for too long. I need to be outside, walking on the Earth, seeing the horizon. This is when I tap into universal truth and cosmic consciousness. The Universe is conscious, and it is outside where I channel this energy and from where I get most inspirations, where I dance in the zero-point. I am free from limiting beliefs and at One with the world. I feel bliss, happiness, Freedom, and love. I feel whole and abundant within myself. I am in charge of my life and happiness. I am steering my ship through the sea of life, letting the wind carry me to the most wondrous destination of my dreams.

Happiness is being free from your past and future. It is the freedom to live in the present moment, the remembrance of your free will to do whatever you wish from your heart. To love what you do or to leave it. You have free will and choice. Becoming fully aware of this will truly empower you.

Happiness is the absence of all low vibrational feelings through your neverending active process of forgiveness, gratitude, and acknowledgement for all lessons learned. Attuning yourself to love will keep your chakras open and activated, which will result in great physical, mental, and emotional health. Allow yourself all kinds of feelings for your self-understanding, healing, and growth. Eventually, let go of all low vibrational feelings such as grief, hurt, pain, frustration, guilt, shame, and fear. Our emotional guidance system always indicates that of which we need to let go and in which we need to invest.

Happiness is the freedom to love. Free yourself from all limiting beliefs about yourself and the world that are not your own, that you were made to believe, or in which you were programmed. With your consciousness attuned to love and your activated chakras, you will feel the truth with your body. You will detect lies and illusions and release that which no longer serves you. You have the wonderful choice to believe what you want about anything. Your beliefs are your reality. Abandon those beliefs that do not serve you. Keep only the beliefs that align with your vibration, your truth. Do not pick up beliefs only because you hear them on the outside. Use your critical mind to determine whether they are true or untrue for you.

Some beliefs apply to people living at a low vibration or are a part of the collective consciousness. You do not have to accept them blindly as your beliefs, but you can accept them to be true for other people. Do not attune to lower vibrational realities but choose your own high vibrational reality. Choose your highest path and timeline.

Beliefs that are based on separation and fear will not affect you in your everyday life if you do not align vibrationally with them or believe in them. Religions, belief systems, and cultures are bestowed upon people from above. They are often picked up without questioning and form our reality. Do not simply believe what other people preach. Find your own truth. Your intuition will help you feel what resonates. If it feels right, if it feels good, then it is for you.

Be free from the conditioning and programming of society and culture. It runs through our lives from when we are born and throughout our school years until we are programmed into the adult world. Have you ever asked yourself why teenagers repel the adult world as if by nature?

We are constantly encouraged to listen to the outside world, where everything seems already prepared for our boring adult lives. Listen to your inner voice and wisdom that every one of us has instead. Step away from your old life and maybe society for a while if you need to get a clear picture from a distance or if you want to look beyond the horizon. Travel and explore. Look at the world. Nothing will open your heart and mind more. Never, ever stop exploring the beauty of the world.

Be free from all sorts of attachments. Dependencies, co-dependencies, and addictions are forms of attachments to things and people. You will notice attachment through a feeling as if you have no control over certain things or people. This is due to deeper wounds, the lack of self-love, and unhealed trauma and pain from your past, which often lies deep and dormant in your unconsciousness. These things can date back to your childhood and previous lifetimes. Your inner-wounded child wants to be healed. If you recognize such patterns in yourself, try to release them through self-love and healing of your past. This is how you can free yourself from old, toxic, unhealthy energies, vibrations, and chords.

Freedom is to be free from attachments to the material world. I value and love beautiful things, but I am not attached to them. This makes a huge difference. There are many people who are so attached to their belongings, places, and houses and who are so stuck inside of their comfort zones that they do not give themselves the chance to discover the world. They have no idea what they are missing. The material world takes up far too much space in our modern Western world. The greatest things in life – love, Freedom, and happiness – cannot be bought for all the money in the world. To me, Freedom is the greatest luxury.

Happiness is the freedom to be your naked self – there are no masks and no roles to please and play to adjust to other people. Your true, unique self has nothing to hide, yet is full of respect, love, integrity, and empathy, living in Oneness with your brothers and sisters and respecting those who are not like you, walking away from those who disrespect or mistreat you, understanding that you attract people into your life as a reflection of your vibration. If we get hurt, it might be a reflection of our own or our mirror's lack of self-love. It is there to teach us self-love and growing boundaries. Stand your ground. Be yourself on every occasion. This is true Liberation – the freedom to be yourself.

Last but not least, happiness means taking things easy. Don't always take things too seriously. Sometimes, it is good just to laugh about it all, and you can never really make a mistake, not even if you want to say now. 'Whatever, I just wanna go out and have some fun.' In fact, this is one of the best things you can do, at your own cost, of course. Life is meant to be fun. You will be fine. Do not worry. Never worry.

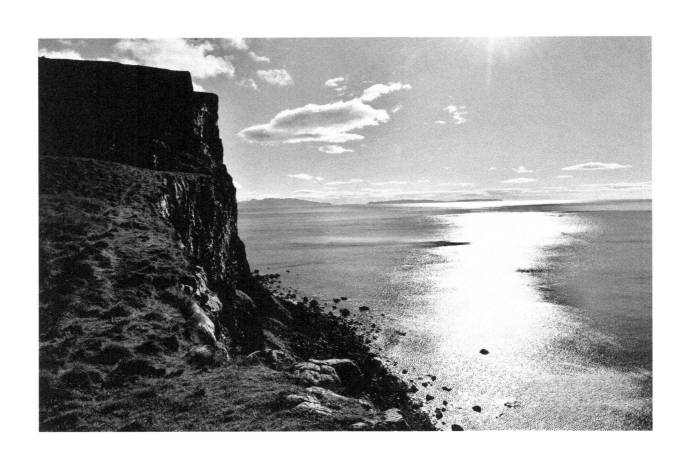

IX. Higher Consciousness

I am a free spirit that cannot be domesticated and kept like a tiger in a zoo. It is my nature to wander around and explore the world, and I feel nowhere better than under the blue sky, the sun, the moon, and the stars.

Everything is energy. The Earth is a lower-dimensional place where energy manifests into shape and form. Your body is merely a physical vessel for your infinite, eternal soul that has incarnated into flesh and blood. You do not end where your body ends. Your soul has powerful spiritual gifts which can be experienced in astral travels, visions, channelling, out-of-body experiences, telepathy, and all of our wonderful creations that come from the heart like music and the arts, creations of your magnificent soul manifested through your extraordinary, physical body. If your soul is unhappy, you become ill. You are a soul in a body – treasure both your soul and your body.

You are unlimited, eternal consciousness connected to all that is. You can only experience Oneness and bliss when you break through the illusion of separation within your consciousness through the opening and activation of your chakras, your energy centres, and through the alchemy of your inner-masculine and feminine energies which may eventually trigger the greatest lifeforce energy. Kundalini energy – it can lead you to enlightenment.

The higher you go in vibration through your expanded consciousness attuned to love – which is the vibration of the Universe – the more Oneness, love, Freedom, happiness, and abundance you will experience. There are different dimensions of reality and timelines that happen simultaneously and coexist together. You find yourself in the dimension and timeline according to your vibration. The lower dimensions are the ones of the matrix and the illusion of separation, whereas in the higher dimensions, only love and Oneness exists. Living at higher dimensions and vibrations gives you a greater perspective, much like a flying bird's ability to see things better than a small animal on the ground would. The higher you go, the bigger the picture gets. At a high vibration or dimension, you have a multidimensional view in which you see how everything is interconnected. You are able to see higher reason and purpose and the stories behind the story. And in the higher vibrations lie your freedom and happiness.

During my spiritual awakening, Kundalini energy that laid dormant in my root chakra was awakened through true love and began rising inside of me. It was the most powerful fire-energy, shooting through my body and radically opening my chakras. I felt as if I had broken through the surface of thin ice into the very depths of truth. My third-eye chakra, my pineal gland, opened, and I suddenly had a multidimensional view. I had my first proper visions and past life memories. My mind became so crystal-clear that I felt as if I could cut through every lie, and for the first time, I experienced different layers of reality and different dimensions with my expanding consciousness and rising vibration.

I realised that reality was not something firm or fixed but something that depended on my vibration and energy. First, I switched between three-, four-, and five-dimensional consciousnesses, which was challenging in my everyday life at the time. I started to have deep insight through my opening third-eye and crown chakra.

I was able to look inside people and through things and read the story behind the story. It was truly shocking in the beginning because everything seemed like the opposite of what I had learned, was taught, and been told until that day. I lived in isolation for a while because my awakening and inner-processes were so intense and impossible for my friends and family to understand. I had to be by myself to go through this heavy experience that changed my life forever, to discover myself, heal myself, and discover the world anew.

I had to work on every fear and painful experience I had ever had, dating back to my very early childhood and from all previous lifetimes, some of which I was not aware. All of this came to the surface for me to clean my energy field from the limiting illusions of separation and the wounds and pain from my past.

After a long winter completely by myself in a cottage in the forest, I was ready to go out into the world again, to jump back into life again. I felt reborn. Over the next years, I travelled to many places to which I felt drawn, where I picked up many memories from different timelines, collected lost pieces of my memory and soul essence, as well as cleared a lot of my karma with places and people. I downloaded and upgraded energies and worked with leylines consciously and unconsciously. Information always came to me through amazing synchronicities and in the form of energy and inner-knowing. These things often happened in the most random places and situations. I was working as a teacher in Russia when I suddenly remembered pieces of the puzzle and understood the deeper sense and higher purposes and found answers to many questions.

Let me emphasise the huge difference between vision and imagination, as I have studied and mastered my mind for a very long time. Imagination is nothing like true vision, downloads of truth, cosmic consciousness, and deep, inner-knowing that you have once you embody your higher-self and when you are in tune with your spiritual self, connected to all that is.

There were many things that blew my mind, but I got used to it, and the intense process of remembrance became much smoother with time. I stabilised at a zero-point consciousness with my higher self in my body. Now, everything is all about living life to its fullest and having fun, embracing every moment, standing in my full power, doing what I love and loving what I do, and loving and exploring the world.

Our consciousness never stops evolving, remembering, and expanding. This is a neverending process. Your consciousness is unlimited and eternal. The more you clear limiting beliefs and illusions, the more you get aligned with your Higher Self, with your soul that is connected to all things and people and the Universe, to the direct offspring of the Source. You experience Oneness and multidimensional truth.

You have a three-dimensional body as well as what is called a light body, as much as you have an aura that some people with activated spiritual gifts are able to see, while others can't. Your consciousness can ascend into the fifth dimension or much higher, where no separation exists.

Your third-eye chakra opens when you remove all limiting beliefs. Through the opening and activation of your upper-chakras, you can channel and download universal truth and cosmic consciousness since the Universe is conscious. With your Higher Self in your body, you will tap into your inner-knowing and remembrance. Through the activation of your lower-chakras, you will stand in your power and manifest what you wish from your heart. You will become an active, powerful, godly, empowered creator.

You will love people equally, and there will be no need to speak about certain spiritual things with people who cannot understand them because they have a different perception and vibration. With an open mind and heart, you will enjoy many kinds of subjects and forms of life. You are not limited to the solely spiritual, but you embrace all facets of life. You live life.

In the end, it does not matter whether you are understood or misunderstood, liked or unliked – all that counts is that you will never be anything but your true, authentic self again. You will never hide away again. You will radiate love, light, and strength. This will have an effect on everybody and everything in your environment. It will inspire others to be themselves too and you will attract people with a similar vibration. Love is the greatest healing power in the Universe. It constantly grows and expands. It leaves nobody unaffected.

Everybody is on their own magnificent, unique journey at their own pace. Everybody fulfils their divine role in this beautiful stage of life that we have co-created together. There is no separation. We are all connected with every single person on this planet. I can only feel love for others when I understand that even those who used to provoke me or make me angry triggered something in me about myself, helping me to grow and remember myself as much as they saw themselves reflected in me. We recognise ourselves in each other's eyes. Let other people be who they wish to be, and let them change at their own pace. Everybody will, eventually.

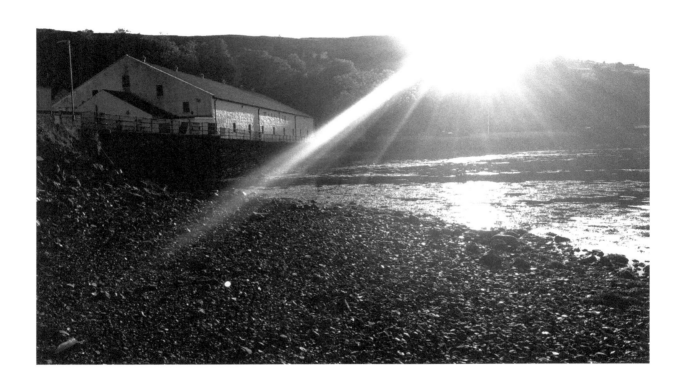

X. The Time is Now

Awake!
Awake from your slumber,
From your lethargy. Step outside,
take your power back, take your life back, take your
happiness back. The sleep is over. The stage of life is yours!

After 2,000 years in the Age of Pisces, we have entered a new age. This is the Age of Aquarius. It started with a cosmic event of the planets, stars, and Earth aligning in new ways. They are triggering the awakening and ascension of humanity and Earth. At the doorstep of this momentum, we are seeing a lot of chaos and rupture. There are many souls leaving the planet; this is the old dying. The new is arising, and it is time to celebrate!

Do not expect this to be reported in the news, but look around you and feel the energy of change, of a fresh wind, of excitement, of life, of the new. The old age was all about power and control over humanity from above, but this is collapsing. You see it in the political leaders who lose their credibility and power and who are no longer capable of leading humanity by means of power and control.

Humanity is rising from below, through the Liberation and awakening of the single individual and through the new awareness of love and unity, standing together and being fully equal, no matter which background or colour. We can now witness the rise of the poor, the unseen, the marginalised, and the outcast. Their voices will get louder, and justice and balance are coming our way.

Be patient, but most importantly, be the change yourself. Inside, you will feel the need to finally break free from the cage into which you have been programmed. You will want to stand up, run and jump outside, and take your life and Freedom back. You will finally want to be yourself again, and you will live your life the way you want. All of this will come from your heart. This is a revolution of the hearts, a revolution of love. The great movement of Freedom. It is happening all around the globe. Do not look behind you. Take your life back. This is how we will bring the change, all of us together. Don't hide from the old world, and don't hope or wait for it to come back because it will not. Create the New World. Your World. Our World.

The new age is about self-empowerment, Freedom, self-realisation, and the remembrance and rise of your godly, creative power from within. Rise above all limits you were made to believe. Rise above all conformity and classifications, putting you into a frame smaller than you actually are. Stop fulfilling a function in a three-dimensional life that is not fun and not your destination. Choose your soul's path. Make your dreams come true. The time is now. Life does not happen to you; make it happen. Create whatever you wish to create from your heart and let the rest flow to you miraculously by the law of attraction, reflecting your beautiful, unique self.

Do not rely on predictions and prognoses about the future you hear from the outside. Observe what happens, but do not let your reality be shaped by anything that does not feel right. Follow your feelings and enlighten the information and beliefs. Turn them around, or let them go.

Choose your beliefs. They are your reality. Create your own beautiful life. How can your life be dependent on politicians that are half as smart as you? How can your life be dependent on anyone other than you? Stop looking for leaders. Lead your own life. Birth this new world, this new reality by being your own liberated self. Free yourself. Take your life back. You free the world by freeing yourself.

The old world of fear, power, and control and the new world of Freedom, peace, and happiness will still coexist for a while. You can choose which timeline and world you live in now. Choose and create your own happy reality through your high vibration. Follow your Freedom, your love, your excitement, your joy.

We are the Age of Aquarius. We have entered the new age. The change on the Earth is happening through and within each person's consciousness, first and foremost. It is

manifesting on the outside, according to the laws of Creation: as within, so without; as above, so below. We are the powerful creators of heaven on Earth.

I did not know about the astrological event beginning the new age, when I embarked on my path of Liberation that started with my spiritual awakening a few years back and involved years of soul-healing and the discovery of myself and the Universe, countless spiritual and physical travels, soul-expansion and ascension, complete Liberation, self-realisation, and the manifestation of the life of my dreams. Still, I felt a profoundness and intensity in my inner-processes and spiritual expansion. I felt connected to the collective in many ways. I knew that I was doing important spiritual work by bringing all energies into Oneness, into love and light, Yin and Yang. I had the deep, inner-knowing that I was doing this for Mother Earth and the collective. In fact, we do this for the whole Universe. We are the Universe.

I often felt heaviness, tingling, and exhaustion in my physical body when I went to places or was surrounded by people and environments that had inherited old, polluted, dark energies of patriarchy, control, and power. I cleared these energies, with my body and mind wherever I went. Imagine your body as a washing machine, working hard to wash clean. That is how it felt. Much of the process is now complete through the amazing ground crew of light here on Earth, who volunteered to do this work together to spread our light. Can you see the stars shining in the dark? The light has won and the happenings of the old world have also taken place because Earth was astrologically in the dark age, the so called Kali Yuga. Now is our time to come and ascend and bring in the new age. Yin and Yang. Both polar sides cannot be one without the other. Everything serves the light. We all wanted to play this game together. Every soul incarnates on Earth to take part in this play for its own spiritual growth and to remember eventually that only love is real.

The world is a reflection of the collective consciousness of humanity. The world shifts along with the shift in the consciousness of mankind. Your shift in consciousness and your Liberation will create ripple effects, affecting your environment and those you meet. Never expect the change to come from outside of you, but be the change. Find your joy and soul-mission by following your heart. Your soul-mission is not something you owe to humanity for the need to be 'good' or to be in service for others. Your soul-mission is born out of the purest joy, and it is a reflection of your true self, born out of love like yourself.

The birth of New Earth is happening through us. The lockdown and the crisis gave humanity the time to get to deeper realisations about themselves and the world. It has given Earth the time to recover from how we have treated her and for us to value and love our planet and each other again, to rediscover true values that have been lost: gratitude, respect, and love. Our birthright to be free, for all the beautiful new ways of living and working in healthy, sustainable, independent, happy, and free ways, and to finally live the life of our dreams, to be a part of the most wondrous movement the Earth has seen in the past few thousand years.

I arrived at my home village at the end of 2020 after a year of travelling and living on the Isle of Skye in Scotland. It was another year of immense learning and adventure. I suddenly knew I had to write the book, which I could have never imagined in my wildest dreams. I had been looking for ways to share what I have learned for quite a while. The idea of writing my book felt great. I just did it! I wrote it down without doubt. I wrote in streams of consciousness from the zero-point in a state of flow, channelling my Higher Self and higher-truth and revealing some parts of my true story for you to

make it easier to believe. I wrote my book in four weeks. I knew that I had to share some very important messages with the world, and very soon. This is an important part of my soul's mission in this lifetime, my greatest passion in all of my lifetimes of fighting for Freedom, and now it is here:

We are free

Thank you

Thank you, my grandmother, Helene, who showed me what unconditional love is and all the beauty and magic of Nature, and thank you, all of my ancestors.

Thank you, my parents, for giving me a body and a name, the most beautiful home, and all the love and support.

Thank you, Romy, my one and only blood sister and the best sister-in-crime in the world.

Thank you, Ella, most beautiful, little, shining star, dancing in the light.

Thank you, my twin flames, for the most amazing journeys, for reminding me of who I truly am, and for making me remember that only love is real.

Thank you, my sisters and brothers of light, my beautiful, beloved soul-family. Thank you for all the inspiration and love. You know who you are.

Thank you, all of my friends, for your critiques and support.

Thank you, my 'opponents', for making my dream come true. I could not have liberated myself if I had not been imprisoned.

Thank you, Mother Earth, for giving us the most beautiful home and garden, and thank you, every precious, living being on Earth.

Thank you, my Spirit Guides, the Angels, the Fairies, and the Star people.

Thank you, the entire Galaxy and Universe.

Thank you, everyone.

WE LOVE YOU

Conscious Dreams
PUBLISHING

Be the author of your own destiny

www.consciousdreamspublishing.com

info@consciousdreamspublishing.com

Let's connect

Lightning Source UK Ltd.
Milton Keynes UK
UKHW050629150721
387042UK00006B/130